# HISTORY of Old Friends

## A Home for Retired Thoroughbreds

# RICK CAPONE

Charleston · London

THE
History
PRESS

Published by The History Press
Charleston, SC  29403
www.historypress.net

Copyright © 2014 by Rick Capone
All rights reserved

Cover image of Michael Blowen and Sunshine Forever courtesy of the author.

First published 2014

Manufactured in the United States

ISBN 978.1.62619.331.4

Library of Congress CIP data applied for.

*In memory of*

*Sunshine Forever*

*1988 Champion Turf Horse*

*and*

*Old Friends' beloved Foundation Stallion*

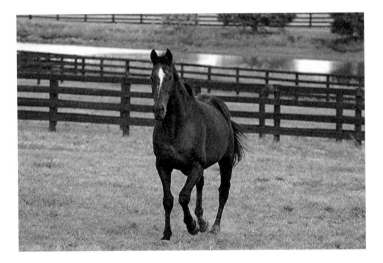

Sunshine Forever. *Courtesy of author.*

# Contents

Foreword, by Michael Blowen                                           7

Acknowledgements                                                    11

Introduction. The Arrival                                           13

Chapter 1. Sunshine Forever                                         19

Chapter 2. Michael Blowen                                           29

Chapter 3. Afton Farm: The Beginning of Old Friends                35

Chapter 4. Ferdinand: The 1986 Kentucky Derby Winner
    and Inspiration for Old Friends                38

Chapter 5. Hurstland Farm                                          41

Chapter 6. Old Friends' First Horses at Hurstland Farm             47

Chapter 7. Dream Chase Farm: Old Friends Gets a Home
    All Its Own                                    58

Chapter 8. Little Silver Charm: A Star Is Born                     64

Chapter 9. The Champions                                           71

Chapter 10. Other Old Friends Retirees, Past and Present           89

Chapter 11. Old Friends at Cabin Creek:
    The Bobby Frankel Division                    118

Chapter 12. People and Events at Old Friends                      124

Chapter 13. Old Friends Comes Full Circle and
    Looks to the Future                           133

# CONTENTS

Appendix A. Miss Hooligan               139
Appendix B. Old Friends: Roster of Horses      145
Notes                  149
About the Author         159

# *Foreword*

It's rare I have the luxury of looking back, as there's so much going on in the present—trying to create more opportunities to retire more of these spectacular athletes. But when I do think back, I believe I'm even luckier than Lou Gehrig. I couldn't imagine that I would be fortunate enough to help Thoroughbreds such as Precisionist and Polish Navy in their final days. Some evenings, I'd take Black Tie Affair, who was suffering from numerous maladies, out of his stall and hand-graze him. I know it's selfish, but it was just me and the wire-to-wire winner of the Breeders' Cup Classic and Horse of the Year getting to spend some time together. I couldn't have been more star-struck if Larry Bird and Magic Johnson showed up.

I remember when we first started Old Friends. Brereton C. Jones, former governor of Kentucky and owner and manager of Airdrie Stud in Midway, Kentucky, was pretty skeptical. He asked if we were going to race, breed, buy or sell the horses, and I answered no in each case. "What exactly are you going to do?" he asked. I told him that I was going to put them in my yard and hope that people will come to visit. His eyes glazed over. Now, more than a decade later, Brere is one of our biggest supporters, and we've been able to retire three former Airdrie stallions—Patton, Afternoon Deelites and You and I—to Old Friends.

One day about eight years ago, Dr. Doug Byars left a $1,000 donation in our office. I had never met Dr. Byars, but I knew his reputation as the premier diagnostic vet in the Thoroughbred business. I called him to thank him for the generous donation and weaseled my way in to talk to him about Old Friends.

That afternoon, over a six-pack of Samuel Adams, he advised me on everything. No, truth be told, he lectured me in the most informative, enlightening way. He's been a friend and counselor ever since. More importantly, he cares deeply about these horses. Since then, Dr. Steve Allday and Dr. Bryan Waldridge have provided dedicated and knowledgeable service.

Along with all the great veterinarians, we're thankful to the Kentucky Horse Shoeing School, which comes out to the farm and, like an army, swarms across the ninety-two acres to trim and take care of all the horses' hoofs.

We're grateful to Lane's End for Gulch, Tracy and Carol Farmer for Commentator and the Japanese Racing Association for helping us bring five stallions to Old Friends after their breeding careers were over: Creator, Sunshine Forever, Ogygian, Fraise and Wallenda. We're grateful to Betty Sue Walters of Afton Farm, Alfred Nuckols Jr. of Hurstland Farm, Charles Nuckols III of Nuckols Farm, Mark and Joanne Pepper of Cabin Creek Farm, Stephen Upchurch and everyone else who helped Old Friends grow from 1 retiree to more than 150.

The volunteers of Old Friends are the human backbone of the farm. Whether it's conducting entertaining, informative tours or doing research on a new retiree, they are absolutely priceless. Old Friends could not possibly exist without them.

We're grateful to Sylvia Stiller, who runs our office with amazing efficiency, organizes all of our events and, basically, keeps all the plates in the air.

Also, thanks go to Janet Beyersdorfer and Kent Ralson for their years of service to Old Friends and, today, Tim Wilson and Carole Oates for managing the farm to new levels since they started early in 2014.

It's fun to meet the jockeys who come back to visit the horses that made them famous: Chris McCarron, Kent Desormeaux, Julien Leparoux, Richard Migliore, Calvin Borel, Jean Cruguet and others. Also, Rosie Napravnik, who sits on our board of directors, raises more money and awareness for Old Friends than anyone.

Sallee Vans has done all of our horse shipping for free ever since we started. Jim Gibbs of Versailles Feed, Home and Garden allowed us to run our feed bill to astronomical heights when money was tight, but he always delivered. Woodford Reserve bourbon is an invaluable partner, and Wild Turkey, through Rosie, has really stepped up to the plate.

We're grateful to sisters Kim Boyle and Aimee Boyle Wulfeck, two supporters of Old Friends who have created one of the premier events during Kentucky Derby week—Ferdinand's Ball—which helps more Thoroughbreds receive a dignified retirement.

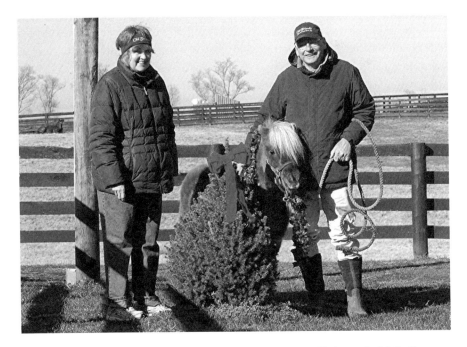

Michael and his wife, Diane, along with Little Silver Charm at Christmas in 2011. *Courtesy of author.*

Ercel and Jackie Ellis, hosts of *Horse Tales* on WLXG radio, invited me to tell stories of our retired Thoroughbreds from the beginning, and having their blessing was a blessing indeed. The media have been great: Bill Mooney, Ed DeRosa, Mary Simon, Steve Haskin, Jay Hovdey, Ray Paulick, *BloodHorse*, *Paulick Report*, *Thoroughbred Times*, HRTV, TVG, CBS, NBC and dozens of others. We owe the most to Mandy Minger of *Daily Racing Form*, whose unwavering support of these animals led to the publication of the *Old Friends* magazine.

Of course, none of this would be possible without Diane White, who, perhaps in a moment of weakness thirty-two years ago, agreed to marry me. From the very beginning, when I asked her to move from Boston to Midway, Kentucky, emptied out her mother's bank account and reduced ours to practically nothing, she never wavered. She loves the horses as much as I do. Today, we *live* together without much money and no regrets.

Finally, thanks to all the horses—especially Sunshine Forever, Precisionist, Marquetry, Black Tie Affair, Invigorate, Summer Attraction and Little Silver Charm—for enriching my life far beyond what I deserve.

In the 1989 Breeders' Cup Turf, Prized and Sunshine Forever lined up next to each other in the starting gate. Twenty-five years later, they lived in adjoining paddocks right outside my window.

In 1995, I drove from Boston to Saratoga to see one of my favorite races, the Sword Dancer Stakes, another long-distance turf race. Kiri's Clown went wire-to-wire to beat Awad by a 1/2 length, setting a new track record. On that day, I couldn't get a seat. Both Kiri's Clown and Awad ended up at Old Friends, and for many years, I had the best seat in the house.

I hope you enjoy reading Rick Capone's wonderful history of Old Friends.

MICHAEL BLOWEN
*President and Founder, Old Friends*

# $\mathcal{A}$cknowledgements

As with any project, this could not have been completed without the help of the many people who love and support Old Friends and its horses.

To start, I'd like to thank the many gifted photographers who generously allowed me to use their beautiful photos in this book: Anne Eberhardt of *BloodHorse* magazine, Digital Assets Coordinator Kevin Thompson of BloodHorse, Matt and Wendy Wooley of EquiSport Photos, Adam Coglianese of Coglianese Photos, Bob Coglianese of Coglianese Photos, Erica Miller of *The Saratogian*, Communications Coordinator Brien Bouyea of the National Museum of Racing, Stan Grossfeld of the *Boston Globe*, Kate Dunn, Laura Battles, Connie Bush, Candice Chavez, Evyonne Baker, Sylvia Stiller and Lord Nicholas Newman.

In addition, many other people took time out of their schedules for interviews and to tell stories of their experiences with Old Friends and the horses. In particular, Marion Altieri, Beth Tashery Shannon, Barbara Fossum, Vivian Morrison, Bea Snyder, Mary Adkins-Matthews, Samantha Siegel, Dr. Doug Byars, Tom Beatty, Tim Ford, John Bradley, JoAnn Pepper, Pat Woodruff-Cohan, Jean White, Dee Poulos and Cynthia Grisolia.

Other big thank-yous go to the Keeneland Library Staff, who helped me gather some initial lifetime past performances of some of the horses at Old Friends to begin my research for this book; Tim Holland and Happy Broadbent from Brisnet.com, who gave me another set of lifetime past performances of Old Friends horses to continue my research; and Mandy Minger and Lonnie Goldfeder at the *Daily Racing Form*, who gave me, and

Old Friends, all of the rest of the lifetime past performances of Old Friends horses to complete my research.

Also, a thank-you goes to jockey Kent Desormeaux, who is a big supporter of Old Friends and who took time for some e-mail interviews.

Finally, the biggest thank-you goes to my friend Michael Blowen, who welcomed me into the Old Friends family on my very first visit back in 2008. Without his friendship and trust in me, I would never have become involved with horses the way I have in the years since we've met, I would not have learned as much about Thoroughbred horse racing as I have, I would not have had the opportunity to write this book and I certainly would not have had the pleasure of being a part owner of Miss Hooligan, one of the mares retired on the farm. Thank you, Michael.

*Note*: 50 percent of the author's royalties for this book will be donated to Old Friends.

Introduction

# *The Arrival*

*October 2004, 2:30 a.m.*

The large steel crate slid out of the cargo hold of the Japanese Airlines 747 and onto the tarmac at JFK airport on an early, cold, damp autumn morning. Marion Altieri, her friend Evyonne Baker, Jimmy Preziosi and a few others stood around waiting to see if the precious cargo contained inside had arrived safely home onto American soil.

The flight crew began working to open up the crate, being careful not to startle the contents inside. Finally, the door to the crate opened, and there they stood—Sunshine Forever and Creator—two big, beautiful Thoroughbred stallions looking around at the new world around them. The twenty-six-hour flight they had just endured did not seem to have bothered them at all.

At first glance, Marion thought to herself that Sunshine Forever seemed to be living up to his name. He was a little thin from his days of stud duty in Japan, but he seemed to be bright, happy and enjoying all the attention. Creator, on the other hand, looked to be in better shape, but he was restless, pawing the ground and snorting loudly.

THE EVENTS LEADING up to Marion standing on the tarmac at JFK at 2:30 a.m. on that October morning looking at Sunshine Forever and Creator had started a few days earlier, when she received a call from Michael Blowen, the founder and owner of Old Friends, a retirement farm for Thoroughbred stallions in Kentucky.

Michael called to tell her that Sunshine Forever and Creator were coming home from Japan, thanks to the hard work of a lot of people, most notably Emmanuel de Seroux, who secured the horses and facilitated their travel. Sunshine Forever and Creator would be the first two Thoroughbred stallions ever to be brought home to the United States to be retired after standing at stud in Japan.

Michael asked Marion if she would go to the airport to meet the two horses and check on their condition, and she felt honored to be able to go and greet them when they arrived. Michael also asked her to give him a call as soon as the JAL 747 touched down. Marion was reluctant to call that late at night, but he convinced her that it was necessary. "After all we'd done, I don't want an extra second to pass without knowing," Michael told her.[1]

On the night of the horses' arrival, Marion and Evyonne got into Marion's car around midnight and headed to the airport. It was freezing outside, and the roads were slick from a cold rain that had fallen all evening. After a short drive from Marion's home in New Rochelle, the two women arrived at the airport and promptly got lost. Jimmy Preziosi, who runs JP Equine Services, a horse transportation company, had told them to meet him at the building where he worked at the airport.

Marion drove "like a bat out of hell"[2] around the back side of the airport, terrified that they were going to miss seeing the horses arrive. When a security officer pulled them over, Marion, ever the optimist, thought, "Oh good, we'll be able to get directions."[3]

The security officer walked up to her car window and asked, "Where are you going ladies?"

"We're going to meet some horses arriving on a Japan Airlines cargo flight," Marion replied.

"Right," he replied. Marion could see by the way he looked at her that he thought she'd been drinking…or worse.

"No, no, no…," she tried to clarify. "We're supposed to meet Jimmy Preziosi of JP Equine Services. He has an office somewhere near the FedEx office here at the airport."

Unfortunately, the security guard didn't know Preziosi or JP Equine Services, so he just said, "Well, please follow me over to our office, and we'll discuss it there."[4]

Marion and Evyonne were getting nervous. New York was still on high alert ever since the 9/11 attacks back in 2001. All she could think of was, "Uh, oh, we're in big trouble."[5] In addition, Marion had been drinking coffee all day long because she knew she was going to be up late, so on top of everything else, she was feeling hyper from all the caffeine.

She followed the security officer to his office. Once there, Marion again explained that they were looking for Jimmy Preziosi of JP Equine Services and that they were waiting for two horses to arrive from overseas. As she was telling the officer the story, she finally managed to find the slip of paper in her purse with the exact address they were looking for. It was the "VetPort—Bldsg. #189/VetPort JFK." Still, the security guard had no record of the place.

Finally, however, another security officer came along and got involved in the conversation. Marion retold her story and said that she was looking for the VetPort at Bldsg. #189/VetPort JFK."

"Oh yeah," the other security guard said. "That's JP Equine Services. That's legitimate. They want to go right over to the building...."[6]

Marion replied, "Yes," and with a huge sigh of relief, she believed that now they would actually get to see the two horses arrive thanks to this news. The two security guards escorted Marion and Evyonne to their destination, where they found Jimmy waiting for them.

According to Marion, Jimmy Preziosi is passionate about horses and is very proud of what he does. Whether it is a great Thoroughbred race champion or someone's favorite trail horse, it's a serious business, and Jimmy works very hard to ensure that everything goes right.[7]

They all piled into Jimmy's SUV and went over to the area of the tarmac where the plane would land and unload. When they arrived, Marion and Evyonne were amazed at how close they were to the runway. FedEx 747s going to Europe were taking off every ten minutes, and they were only one hundred yards away. The noise exploded in their ears.

Jimmy yelled, "There it is!" And right there, just on the other side of the tarmac, the JAL 747 plane landed right in front of them.[8] A few minutes later, the plane pulled up close to where they were standing. Almost out of nowhere, many workers appeared and began scurrying around doing their jobs. There was a lot of activity, as one set of workers went about checking the plane over, refueling it and getting it set for the next flight. Meanwhile, another set of workers began opening up different cargo doors to begin the process of unloading it.

Soon, the steel crate with the two horses came out of the cargo hold, and two members of the flight crew struggled to open the doors of the crate. After some work, the doors opened, and there, after all the hard work it took to bring these two horses home, stood Sunshine Forever and Creator. They were home on American soil.

All in all, Marion thought, they seemed to be in good shape, but she still had one more thing to do. She reached into her pocket, pulled out her cellphone and dialed the person who had started it all.

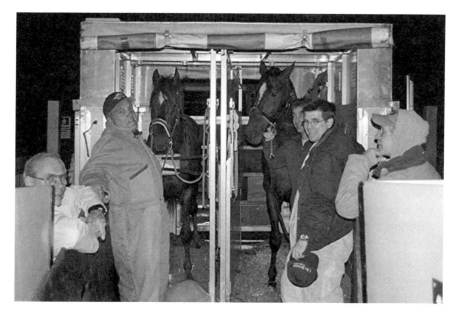

This image is the only photo in existence that shows the arrival of Sunshine Forever (right) and Creator at JFK Airport in October 2004. Their final destination: Old Friends. *Courtesy of Evyonne Baker.*

BACK IN KENTUCKY, Michael Blowen had been unable to sleep and found himself alternating between pacing around his house and watching late-night television—waiting…and waiting…and waiting. He had hardly slept at all the night before either.

In some ways, it seemed like he hadn't slept for weeks, and he was getting nervous because he had expected Marion's call much earlier. He was worried. It was like a father waiting for his teenage son to come home after he took the car out by himself for the first time. "Nerve wracking," recalled Blowen.[9] He had told Marion to call him no matter what. He didn't care what time it was when the two horses arrived; he just wanted to know how they looked and how they were doing. A little past 2:30 a.m., his phone rang.

"They're here!" said Marion.

"What happened?" Michael asked.

"The plane had to make a fuel stop in Alaska, which lasted two hours," Marion replied. "It was a longer stop than expected."

Michael found himself uncharacteristically speechless. There was a long pause before he finally asked, "How do they look?"

"Well, they look all right," she replied.[10] Later, Michael would laugh to himself about his question because he half-expected her to say, "They look like you'd look if you came halfway around the world to come to JFK and land at 2:30 in the morning."

Michael thanked Marion and hung up. Relief washed over him. He knew the horses were safe and that they would soon be in Kentucky at Old Friends. But he was still "all wound up" and found that he still could not go to sleep.

After waking up his wife, Diane White, and telling her the news about the horses arriving safely, he sat down and started flipping through the TV channels, watching a little of ESPN's SportsCenter, a short part of a movie, a little news and whatever else he could find.

In reality, though, he wasn't even concentrating on what was on the television set, as his mind was going one hundred miles an hour. He thought about all the hard work and the efforts of the many people it took to accomplish the goal of bringing Sunshine Forever and Creator home. It was such an amazing, triumphant feeling. It is the way, he imagined, Thoroughbred owners must feel when they win the Kentucky Derby.[11]

AFTER MARION hung up the phone, she continued to watch the activity surrounding the horses. She even met the groom Jimmy had sent over to take care of the horses. While the workers prepared to get the horses off the plane and onto a trailer, the groom fed and petted them, keeping them calm as the crew prepared to get them off the plane.

Now, before the horses could make their way to their final stop in Kentucky, they would have to go through quarantine, and the preparation for quarantine fascinated Marion. A horse's hoofs cannot touch American soil until after the horse has been examined and has been in quarantine for a specified amount of time. Sunshine Forever and Creator would need to be in quarantine for three days in New York before being sent to Old Friends to complete the quarantine period.

To ensure that the horses' hoofs did not touch the ground, the crew built a series of ramps from the plane down into the trailer that the horses were to be loaded into for the trip. Lining the ramps were seven veterinarians dressed in Hazmat suits, each of whom had a different task. One gave the horse shots, another checked their glands and throat and another listened to their hearts. All these men had volunteered their time to meet these two horses for Old Friends.

The veterinarians completed their jobs, and the horses were loaded safely into the trailers for their short journey to quarantine. Marion smiled as she

saw that Sunshine Forever was alert, looking around and enjoying everything going on. "He's just so sweet," she thought to herself.[12] Meanwhile, Creator continued to snort and paw at the ground. He still seemed restless and unsure of all that was going on. Sunshine Forever kept looking over at him, softly nickering. One of the vets joked that Sunshine Forever seemed to be saying, "Creator, what's your problem? This is nice. We're going someplace fun, I bet."[13]

Sunshine Forever and Creator were now in America. They were home, they were safe and, after a short stay in New York, they would both soon be heading to Kentucky to enjoy the rest of their lives at Old Friends.

## Chapter I
# Sunshine Forever

It was a cool spring morning as the sun rose over Dream Chase Farm, the permanent home of Old Friends in Georgetown, Kentucky. The morning dew on the grass sparkled as the sunlight shined on each of the paddocks.

The horses in each paddock quietly grazed on the grass or walked along their fence line eagerly waiting for Michael Blowen, the founder of Old Friends, to bring them their morning feeding of Triple Crown Senior and a dash of Succeed.

Sunshine Forever stood serenely in his pasture, grazing on the lush Kentucky bluegrass. When he first arrived at Old Friends, Sunshine was thin, with some of his ribs showing. Now he looked fit and beautiful, with the sun glistening on his dark-brown coat.

Breeding farms had their foundation sires, and for Old Friends, Sunshine was its retired foundation sire. He was the one Michael had chosen to bring home from Japan first, and he was one of the first stallions to be retired to the farm. Sunshine was there from the beginning of Old Friends, and he seemed to understand his place on the farm living right outside Michael's front door.

"He was my favorite horse," said Michael. "He was the first horse we ever brought home from Japan after his breeding career was over, so he set the standard. He wasn't the friendliest horse; he wasn't a big pet or anything, but I had such a great deal of respect for him."[14]

Sunshine paused from his morning grazing, looked up and then took off at a full gallop around his paddock, his mane and tail gracefully flowing out

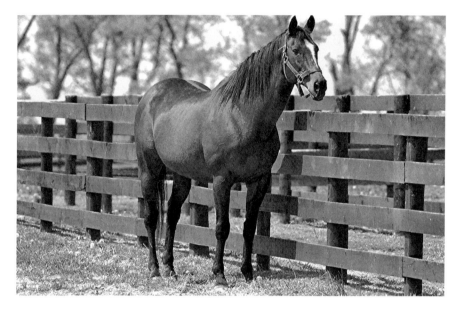

Sunshine Forever, Old Friends' foundation stallion, lived on the farm for almost ten years before he passed away in January 2014. *Courtesy of author.*

behind him. The strength of the muscles in his legs, shoulders and haunches showed just how fit he had become since he first arrived home to the United States after a long flight from Japan.

As fast as he began his run, he slowed to a trot and then a walk along his fence line. Slowly, he then moved away from the fence and looked around, surveying the sights around him; then he began to graze on the grass once again.

SUNSHINE FOREVER was born on Thursday, March 14, 1985, on a chilly winter morning at Darby Dan Farm in Lexington, Kentucky, a son of Roberto, out of Outward Sunshine by Graustark.

Bred by John Galbreath, he grew up as any other Thoroughbred colt, happily running around the rolling hills and grass fields of his farm with his mother until he was weaned and began training for his future as a racehorse. Little did anyone know at the time that this little dark-brown colt would turn out to be an Eclipse Award–winning champion. It certainly didn't start out that way.[15]

The start of Sunshine's 2-year-old campaign in 1987 was very discouraging. His trainer, John Veitch, ran Sunshine five times that year, all in Maiden Special Weight races. His first three races, two at Saratoga and

one at Belmont, were six- and seven-furlongs on the dirt. With Jerry Bailey as his jockey, Sunshine did not do well at all, with his best finish being a fifth at Belmont in his third outing on September 9.

On October 16, Veitch made two interesting changes to Sunshine's racing program. He switched Sunshine over to the turf course at Belmont for another Maiden Special Weight race, and he decided to try him at a 1-1/16 miles.

The changes worked. Sunshine loved the grass and the distance. With Bailey as his jockey, Sunshine ran strong, moving to the outside midway through the final turn, and took the lead with just a furlong to go. Unfortunately, he just could not hold the momentum and was beaten by 5-3/4 lengths by Smart Lad to finish second. Still, it was his best race to date.

Veitch took Sunshine to Florida to end the 1987 season. Even though Sunshine had done well on the grass, Veitch decided to put him on the dirt at Hialeah Park in a 1-1/8-mile Maiden Special Weight race on December 17. With Walter Guerra riding him for the first time, Sunshine finished in the money once again, taking third place.

Sunshine completed his first year having run five times, finishing in the money twice and earning $6,820. He finished up 1987 with his two best races, and while he hadn't won yet, everyone was hopeful that he would carry his newfound momentum into his 3-year-old season.[16]

Monday, April 25, 1988, was the day chosen for Sunshine's first race as a 3-year-old. To start the season, Veitch made another crucial decision. He gave Hall of Famer Angel Cordero Jr. a leg up, and the horse and jockey became the horse racing equivalent of the Boston Celtic's Kevin Garnett and Paul Pierce.

It was a sunny, mild day at Aqueduct Race Track as Cordero mounted Sunshine for the very first time for a Maiden Special Weight 1-1/16-mile race on the turf. Sunshine ran comfortably for the first six furlongs. As they headed down the backstretch, Profit by Entry worked his way into the lead around the far turn and into the homestretch. It was then that Cordero urged Sunshine to run harder, and the horse responded by blasting down the homestretch. He caught Profit by Entry as if that horse was standing still and crossed the finish line still pulling away from the field to win by three lengths.[17]

After three more impressive efforts, which included the Grade 2 Saranac, where Sunshine finished in second place, Veitch decided to send Sunshine out into his second graded stakes race—the fourteenth running of the Hill Prince, a $100,000, Grade 3, 1-1/16-mile run on the Belmont turf. Sunshine would also face off again with Posen, the horse that beat him in the Saranac.

Posen broke ahead of Sunshine once again, running strong heading into the wide final turn at Belmont. However, this time Sunshine had an extra half furlong to catch his rival. Near the top of the stretch, Sunshine flew by Posen, winning by an impressive six lengths.[18] With that win, Sunshine had won four of his first five races in the '88 racing season and was definitely living up to the promise everyone expected.[19]

Veitch kept Sunshine on the same grueling schedule and decided to run him a little more than two weeks later on July 10 in the twenty-fourth running of the Lexington—a $100,000, Grade 2, 1-1/4-mile race on his favorite surface, the Belmont turf. In the race, Sunshine took the lead in the middle of the homestretch and then pulled away to win by 1-3/4 lengths.[20]

Veitch confidently moved his colt up to his first Grade 1 stakes, the $200,000 thirteenth running of the Grade 1 Sword Dancer Handicap. It was a 1-1/2-mile run on the Belmont turf on July 30. Unfortunately for Sunshine, the day belonged to another horse, Anka Germania, who took the lead around the final turn and never gave it up. While Sunshine ran wide around the final turn, and even had to drop back a little to avoid some contact, Anka Germania had too much of a lead; Sunshine, though charging hard, had to settle for second by 1-1/2 lengths.[21]

While he didn't win, Veitch was still impressed with how his horse ran and decided to keep him running at the Grade 1 level, entering Sunshine next in the eighth running of the Arlington Mile on August 20. The race would be a 1-1/4-mile test on the turf at Woodbine Race Track. The race also marked the first time Cordero would not be aboard, as he had another commitment, so Veitch chose Jorge Velasquez.

Whether it was having a new jockey, running on a new track or just "one of those days," Sunshine just wasn't on his game, finishing third behind Mill Native and Equalize. It was a tough finish, but Veitch, undeterred, was not worried and aimed his horse toward his next Grade 1 race, the thirtieth running of the Man O'War Stakes, a 1-3/8-mile, $500,000 turf race on September 24 back at Belmont with Cordero back on board.[22]

Face Nord took the early lead in the Man O'War Stakes, but Sunshine caught up and passed him in the backstretch, holding the lead around the far turn and into the homestretch. There the race turned into a duel between Sunshine and Pay the Butler, who began a charge of his own. But Sunshine held on to win by a half length, the closest win of his career.[23]

The victory was also the biggest of Sunshine's career and established him as one of the top turf horses in the '88 racing season. But his best was yet to come.

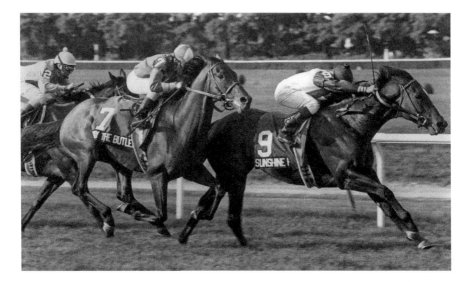

Sunshine Forever winning the 1988 Man O'War Stakes at Belmont Park. *Courtesy of Bob Coglianese Photos; appeared in* BloodHorse *magazine.*

For his next race, just fifteen days later on October 9, Veitch ran Sunshine in the Turf Classic at Belmont. The 1-1/2-mile turf race was another Grade 1 affair for $500,000. In addition, two of Sunshine's previous foes, Pay the Butler and Anka Germania, would be aiming for him.

Sunshine quickly opened up a lead out of the gate in the race and, for the first time in his career, dominated, going gate-to-wire for the win. The only close moment came when River Memories took a very brief lead around the six-furlong mark. But Cordero got Sunshine's attention, and the horse went on to win by 4-3/4 lengths over second-place finisher My Big Boy. Neither Pay the Butler, who finished fifth, nor Anka Germania, who finished seventh, were much of a factor.[24]

However, as solid a performance as the Turf Classic was for Sunshine, it would be his next race that would turn out to be the defining moment of his career. With just over a two-week break once again, Sunshine headed for the 1-1/4-mile thirty-seventh running of the Budweiser International on October 23. The Grade 1 turf race at Laurel Race Track had a total purse of $750,000.

The Sunday of the race dawned cool and crisp as preparations got underway. The day warmed up and turned into a beautiful sunny autumn afternoon as the horses were led out to the track for the post parade. Cordero

proceeded to go through his regular race preparations, warming Sunshine up to make sure the horse was ready to go from the start.

The horses finished their warm-ups and slowly made their way up the track, where the handlers efficiently loaded them into the starting gate. Once they were settled in, time seemed to stand still for a second until, finally, the starter pushed the button. The bell rang, the gates slammed open and the horses exploded out of the gate.

Sunshine broke nicely and stayed near the front of the field around the first turn and down the backstretch. Then, at the far turn, he slipped between horses and took the lead heading into the stretch. Coming down the stretch, a French horse named Squill started charging after Sunshine on the outside, while on the inside, Frankly Perfect also began to gain ground.

Squill was the first to make a move on Sunshine at the sixteenth pole. He ran past Sunshine on the outside and opened up almost a one-length lead. About the same time, Frankly Perfect passed Sunshine along the rail, but still behind Squill.

Now, usually when a horse gets passed in a race, especially if the horse is in between the two horses passing him, that is pretty much the end of the race for that horse. But that was not the case with Sunshine in this race, and the result was one of those indescribable moments in horse racing that leaves spectators awestruck and standing on their feet cheering and yelling.

As all seemed lost for Sunshine, he dug down deep within himself, drew deep breaths of air into his large, barreled chest and slowly began to work his way back between the two horses, passing Squill and then desperately charging ahead to catch Frankly Perfect as the finish line approached.

At the wire, Sunshine just got out in front by a neck to win the race, while Frankly Perfect finished second and Squill finished third.[25] Sunshine's win in the 1988 Budweiser International would become one of the great Thoroughbred performances in racing history. While he would race seven more times over the next two years, the 1988 Budweiser International became his crowning achievement. It was also a race that Michael had gotten to see and that made Sunshine one of his all-time favorite horses in racing.

Two weeks later, on November 5, Sunshine found himself running his heart out once again, this time at Churchill Downs in Louisville, Kentucky, in the $2 million Breeders' Cup Turf.

From the start, Great Communicator and Sunshine made this Grade 1, 1-1/2-mile affair a match race. Great Communicator took the early lead, while Sunshine made his move, desperately trying to catch up to his rival. He got close, but each time, jockey Ray Sibille urged Great Communicator

onward, and the two noble athletes battled side by side to the wire. In the end, Great Communicator beat Sunshine by just a head.[26]

The Breeders' Cup Turf race was the final outing for Sunshine in 1988 but not the end of his season. Just a few weeks later, Sunshine was awarded the Eclipse Award as the 1988 Turf Horse of the Year to cap his great racing year. It was a season that saw him race twelve times and never finish out of the money. He won eight races, was second three times and third once, while collecting $2,032,636.[27]

As good a season as 1988 was for Sunshine, 1989 would not be a memorable one for the now 4-year-old colt. All season long, he would continually battle minor, annoying injuries. But as he always did, Sunshine gave everything he had; he just couldn't come close to replicating his grand performances from the year before.

Sunshine ended his 1989 campaign trying to defend his championship in the Budweiser International and trying to avenge his defeat in the Breeders' Cup Turf. In both cases, he came up short, finishing in last place by 14-1/2 lengths in the Breeders' Cup Turf to, interestingly enough, Prized, who now lives in a paddock at Old Friends very close to Sunshine's paddock.[28]

While Sunshine's final year on the track was not a memorable one, his complete racing career was one for the history books. In his three years on the track, Sunshine ran in twenty-three races and finished in the money seventeen times, getting eight wins, six seconds and three thirds. He had collected $2,084,800 in prize money, while winning three Grade 1 races in the Turf Classic, the Man O'War Stakes and the Budweiser International.

In addition, he finished second in the Breeders' Cup Turf (G1), the Sword Dancer Handicap (G1), the Saranac Stakes (G2) and the Canadian Turf Handicap (G2), as well as third in the Arlington Million Stakes (G1) and the Fort Marcy Handicap (G3).[29]

A few weeks after the 1989 Breeders' Cup, near the end of November, Sunshine was retired to stud at Darby Dan Farm. While Dan Galbreath and Phillips Racing still retained ownership of the horse, around the time of the Breeders' Cup, they had sold 50 percent of his breeding rights to Carl Icahn, the owner of Fairfield Farm.[30]

Sunshine would stand at Darby Dan for six years until 1995, when he was sold and sent to CB Stud on the island of Hokkaido in Japan. The owner, Dr. Koichiro Hayata, took good care of Sunshine but eventually sold him again and sent him to a small, two-stallion farm on the island of Honshu in Aomori Province near the U.S. Military Base at Misawa.

Sunshine's stud career, unfortunately, did not live up to his success on the track, which probably aided in the decision to send the horse to Japan in the first

place.[31] During his stud career, Sunshine sired 318 foals. Of those, 153 found the winner's circle, but none was a champion. Not one was as good as his or her sire.

Sunshine stood at stud in Japan for almost a decade when events began to take place that caught the attention of Michael Blowen in the United States—events that would soon bring Michael and Sunshine Forever into each other's lives.

It was a little after 10:00 a.m. one morning as Michael walked the first tour of the day around Old Friends. Sunshine Forever's head popped up as he heard Michael's voice coming toward him, and the horse quickly spotted him at the head of the group of tourists heading his way carrying a now familiar red bucket.

Instinctively, Sunshine knew what that meant—carrots and lots of attention. The beautiful dark-brown stallion began to slowly walk toward the fence to meet Michael and the farm's guests. He didn't walk too fast—he is a former champion after all, so he has to hold on to his dignity—but inside he knew that treats awaited him once he reached the fence.

Michael slowly walked his guests up to Sunshine's paddock and began to tell them the story of the great champion. You could tell by the way Michael and Sunshine interact that the horse enjoys Michael's company just as much as Michael enjoys the stallion's company.

Michael has a wonderful way with animals. While the former champion will come over to greet any of Michael's staff when tourists come around (the carrots help), it is with Michael that he is most comfortable.

Still, it is also no surprise that Sunshine is Michael's favorite horse. After Sunshine arrived at Old Friends, he gradually warmed up to Michael. It was as if he finally said, "Okay, I'll trust this guy." In return, Michael has done all he can to try to not do anything to violate that trust.

Michael is also the only one on the farm that Sunshine will allow to hold his lead rope when the veterinarian comes to examine him. He'll stand patiently, watching the vet with a wary eye, but he'll stay there and allow the vet to do his job. Michael takes great pride in that trust.

"It's hard to explain my relationship with Sunshine because I adore him," said Michael. "I like the way his eyes look. I like the way he handles himself. And he was just such an amazing athlete, and the idea that he lets me hang out with him is just unbelievable."[32]

As Michael continued to tell the visitors stories about Sunshine's race history, the horse stuck his head over the fence, nuzzling Michael's hands

looking for his treat. Michael dug into his bucket of carrots, and Sunshine quickly scooped them out of Michael's hand and munched away. Michael continued talking for a few minutes, while quietly feeding Sunshine a few more carrots and patting him on the muzzle and neck.

One of the stories Michael is fond of telling visitors is when, shortly after Sunshine arrived, a local TV station did a story about him and Creator coming home. After it was broadcast, Michael received a call from a woman who left a message saying that she saw the story on the news about Sunshine Forever and that she used to take care of him when he was at Darby Dan. She said that the day he left for Japan was one of the saddest days of her life, and after he left, she took his paddock sign down and put it away.

When she saw Sunshine on the news and knew that he was home in America and living at Old Friends, she was ecstatic. The next day, she came over to Old Friends, and when she saw Sunshine again after all those years, she just began to cry. She gave Michael his old paddock sign, and it now hangs on a stall in the barn.[33]

As the visitors continued to stand and listen to Michael and look at Sunshine, Michael suddenly turned, looked at Sunshine and asked the horse, "Are you the greatest horse on the farm."

Without missing a beat, Sunshine nodded his head up and down as if to say, "Yes!" Michael laughed and gave Sunshine a couple more carrots. It's a trick he and Sunshine have been performing for visitors for years.

"The first time that happened was when Richard Schlesinger came here with the *CBS Evening News* to do a story about Old Friends, and we were just goofing around," said Blowen. "Then Schlesinger said, 'What do you do?'"

"I said, 'Oh, I don't do anything. I just feed them carrots and talk to them.'"

"Schlesinger asked, 'Well, what are you going to say to him?'"

"I said, 'I don't know. I'll ask him a question.' I asked him, 'Are you the greatest horse on this farm?' And (Sunshine) nodded. So, then I gave him a carrot. Well, Sunshine's smart. So, now, every time he does it, he gets a carrot."[34]

As Michael finished telling the visitors Sunshine's story, he gave the big horse one last pat on the neck and began walking down the path between paddocks to the next horse on the tour, who was already standing with his head over the fence waiting to greet the guests and get his own share of carrots. Sunshine followed along the fence for a while, watching the visitors walk away.

One visitor stopped for second as the group moved along and then walked back over to the fence where Sunshine was walking. The horse saw this, stopped and put his head over the fence once again. The visitor tentatively

reached out toward Sunshine and let him sniff his hand. Then he slowly began to pet his muzzle and then along his neck.

Sunshine kept a wary eye on the visitor and allowed this to go on for a few seconds. Then he pulled his head back over the fence and began to slowly walk back out to the middle of the paddock to find another nice patch of grass to graze on.

You could tell by the smile on the visitor's face that the moment he just shared with Sunshine was a special one for him. It would be a memory he'd take with him as he left Old Friends that morning and a story he'd tell all his horse racing friends about in the days to come. The visitor turned and headed down the path between paddocks to rejoin the tour, while Sunshine continued to graze.

Life at Old Friends was good for Sunshine, as well as for all the other Thoroughbred retirees that now called the farm home. However, for Michael, achieving his goal of not only creating Old Friends but also finally having a permanent home for the organization did not seem possible at times. But with a lot of hard work, the long road from former *Boston Globe* movie critic to successful Thoroughbred retirement farm owner finally did come to fruition, and the results have been more than he could have ever imagined.

## Chapter 2

# Michael Blowen

In his years working as a movie critic at the *Boston Globe*, Michael Blowen met, interviewed and talked to hundreds of people in the movie industry, including producers, directors and movie stars. It was an enjoyable period in his life, especially when he got to hang around with stars like Jack Nicholson, Angie Dickinson and others and become longtime friends with many of them.

While working at the *Globe*, Michael also had the good fortune to meet Diane White, a columnist at the *Globe*, and the two would eventually get married. Later, Michael would start writing a column at the *Globe* about everyday life in the city. But then, one day, Michael's whole life changed forever.

Michael's editor at the *Globe*, Robert Taylor, asked him if he'd ever been to a racetrack before. At the time, Michael had never been to one, and he just wasn't interested. "I loved sports, but I never liked horse racing, and whenever a horse came on the cover of *Sports Illustrated*, I threw it away," he said on a sunny afternoon sitting at a picnic table at Old Friends. "I just wasn't interested. I thought it was stupid."[35]

However, since it was his boss asking, he agreed to the trip to the track one Sunday afternoon, and "I fell in love with it immediately," he said.[36] Little did he know then, but Michael's journey to a lifelong love affair with Thoroughbreds had just begun.

In fact, after that trip to the track with his boss, Michael loved the horses and the track so much that he began going just about every Sunday. He even

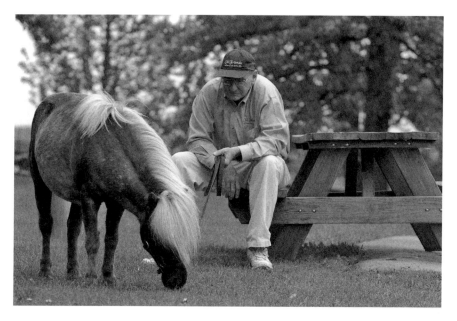

Michael Blown takes a break from a busy day to relax with his buddy, Little Silver Charm. *Courtesy of author.*

became pretty good at handicapping and had some success. Then came the fateful day in 1997 when he bet on a horse called LinePro.

"IT WAS FEBRUARY at Suffolk Downs," Michael recalled. "It was a miserable day. The rain was coming down, it was snowing, it was sleeting…it was a mess. And the poor horses were soaked. The trainers and everybody were soaked, and it was cold and the horses were running for no money. It was just awful."[37]

Then Michael made a bet—a big one for him at the time. It was a twenty-dollar bet to win on LinePro, who had 8-to-1 odds on him. He also keyed LinePro in a trifecta with another horse, and it cost him another twelve dollars, for a total of thirty-two dollars on the one race.

The race went off, and LinePro won. In addition, the two other horses Michael had bet on came in, and they included a 40-1 long shot and a third long shot, giving him the trifecta. He thought he'd hit it big, until they disqualified LinePro and dropped him to second place. Now, in situations like that, some folks scream, others jump up and down and some throw their programs. Michael, on the other hand, just got up and took a walk.

His walk led him down into the lower levels of Suffolk Downs, where he ran into Carlos Figueroa, a trainer he had written a profile about for *Spur* magazine the year before. The two men began talking that day, and "out of the blue," Michael asked, "Carlos, if I came to work for you, will you teach me about horses?" According to Michael, here's how their conversation unfolded:

> *Carlos looked at me and said, "Yeah, you can. But you're going to have to pass a test. You have to come on Monday. You have to be there at six o'clock [in the morning], and you have to pass the test."*
>
> *I asked, "Pass the test? I didn't even start yet."*
>
> *Carlos replied, "You have to pass the test on what it takes to survive on the backside."*
>
> *I said, "Well, I don't know about that."*
>
> *Carlos then explained, "I'm going to tell you what the answer is now. You just have to remember it between now and Monday."*
>
> *So I asked, "Okay, what is it?"*
>
> *Carlos simply said, "Lie, cheat and steal. Those are the three things you have to know."*[38]

At the time, Michael thought Carlos was joking. But Carlos was serious, and it turned out to be a lesson that Michael learned well.

So, that Monday, Michael showed up at Carlos's barn at 6:00 a.m. His "teacher" was asleep in a car, so he opened up the barn and knocked on the tack room door. Jimmy Tuck, Carlos's groom, stuck his head out, looked at Michael, wondering what this guy was doing there, and just said, "Yeah?"

"I've come to work for Carlos," Michael replied.

Tuck just shook his head and just said, "Oh no, oh no, not another one."[39]

And that's how Michael's life with horses began. He'd go to Suffolk Downs to work each morning with the horses until 8:15 a.m. and then get on the subway, head to the *Boston Globe*, change his clothes and be at his desk by 10:00 a.m. Since he was a movie critic and columnist, he had flexible hours, which worked to his advantage.

To this day, Michael always recalls the words of his friend and co-worker Alan Berger: "You know what is amazing about this? You don't know where this is going to lead."[40] Those words would turn out to be prophetic for Michael.

When Michael started working with horses, he was afraid of them. They were big animals, and he didn't know what he was doing or where to

get started. He quickly realized he would have to do like all of the others who came before him—watch how others did things and learn on the job.

On his very first day, Carlos told him to go take the bandages off one of the horses. Michael walked up to the horse and wondered what to do next. "Oh, this is unbelievable," he thought to himself. "This is a big horse. He could kick me—and, it looks like he wants to."[41] In addition, at the time, Carlos didn't use the easy-to-remove Velcro bandages. He did it the old-fashioned way—with safety pins, which, of course, makes it even harder to get the bandages off, especially for a first-timer like Michael.

Luckily for Michael, there was a guy in the barn nicknamed "Mud Bug" who showed up and helped him out. Mud Bug was a jockey from Louisiana and knew his way around horses.

"Hey, what are you doing," Mud Bug asked Michael.

"I'm trying to get the bandages off this horse, but I'm not sure where to start. It's my first day," Michael replied.

"Well, here, let me give you a hint," Mud Buck said, and he leaned over, lifted up one of the horse's legs and said, "Horse can't kick you on three legs." Michael had just learned his first lesson about horses.[42]

SOME YEARS LATER, Michael got the chance to go down to Kentucky for the first time to write a story about a horse named Saratoga Character. He had taken care of the horse at Suffolk Downs, and after the horse was done racing, he ended up in the Thoroughbred Retirement Foundation (TRF) program and was retired in Kentucky. It was an organization that Michael began to really admire for the work it was doing rescuing Thoroughbred horses, something in which Michael had become interested.

One of the things that really bothered Michael in his work at the track was what happened (but was not talked about) to horses that had reached the end of their racing days. One day at the track, he was witness to a horse being loaded onto the truck that would take horses "away." The truck would show up from time to time. They would load the unwanted horses onto it, and it would take them away to slaughter. That was what was happening on this day.

What caught Michael's attention mostly were the sounds of the screams the horses made as they were being loaded onto that truck. Michael truly believed that those horses knew what that truck meant for them and where they would be going. Michael said it was the most heart-wrenching, horrible sound he had ever heard. It was a sound you would hear in your worst nightmares, he recalled, and one he just never wanted to hear again.

When the *New York Times* bought out the *Globe*, Michael and his wife, Diane, who was a columnist at the *Globe*, took the company buyout. As an early "retirement" present to himself, he gave himself a trip to the Belmont Stakes, where he saw Point Given win.

However, during the weekend, he also had dinner with Elinor Penna, who was working on an auction for the Thoroughbred Retirement Foundation. During the dinner, she mentioned that the TRF needed an operations manager and offered him the position.

"Well, I had never done anything like that before, but what have I got to lose now," he thought to himself. "I'll give it a shot."[43]

So, the next day he called Diane and told her about it. He took the job, and soon after, the two moved to Kentucky and began working for the organization. Interestingly enough, the job eventually saw him cross paths with his mentor, Carlos Figueroa, once again.

One day at his new job with the TRF, Michael was authorized to go to Rockingham Park and spend $5,000 to get as many horses as he could that were destined for slaughter. He went there with the TRF treasurer, Ray Roy, who had the checkbook, and the two picked up a few horses from his old friend and mentor, Carlos Figueroa, as well as some other horses from a couple other guys, filling up the truck.

However, there was one other horse that Michael really, really loved and wanted to get. Her name was Wedding Punch. She was a beautiful young gray horse that had broken her knee. Michael knew that she wasn't going to race anymore. Ultimately, he knew from past experience working at the track that she was destined for the slaughterhouse.

Unfortunately, there wasn't any room left on the truck, and besides, Carlos wanted $1,000 for her. But then came a stroke of luck. At the last minute, one of the other trainers decided that he wasn't going to give them a horse he planned to give them, which opened up a space on the trailer. Michael now had his chance to get Wedding Punch, but he had to think fast to get it worked out.

So, there they all stood—Michael, Ray and Carlos. Close by was the truck, with its engine running, and the other horses were already loaded on the trailer. Standing next to them was Wedding Punch. Michael looked at Carlos and said, "I'll tell you what we'll do. I'll get you the $500 from the TRF, and then I'll give you $500 in cash of my own money for Wedding Punch. You'll get $1,000, which is more than you'll get from the slaughterhouse. Besides, you know she's not going to run anymore."

Carlos just looked at him and said, "You're terrible."

Finally, Carlos agreed.[44] Quickly, Michael got Wedding Punch loaded onto the trailer, got the check for $500 from Ray and gave it to Carlos while the truck pulled out, taking the young horse to a nice retirement in Kentucky.

Carlos then turned to Michael and asked, "Okay, where's the other $500?"

Michael just smiled, looked at his former teacher and said, "Lie, Cheat and Steal."

Carlos kind of laughed and was appalled at the same time, but then he said, "Oh my God, you learned too well."

"It was a wonderful moment, I have to say, as a proud graduate of Figueroa University," Michael said with a chuckle.[45] In case you are wondering, there were no hard feeling between the two men. In fact, Michael and Carlos are still very good friends to this day and talk frequently.

# Chapter 3
# *Afton Farm*

## *The Beginning of Old Friends*

While the work at the Thoroughbred Retirement Foundation was rewarding for Michael, the idea of starting Old Friends began to form in his mind. One of the things he noticed working at the TRF was that most retirement farms would not take stallions. They are harder to handle and require their own separate paddocks, which means more space; as a result, people would not take them in. For that reason, he began to look into starting his own Thoroughbred retirement farm where stallions would be welcome.

With that in mind, Michael began to try to figure out how to create such a place. To start, he talked to people and told them about the idea he had to create Old Friends and accept stallions. While Michael thought it was a flawless idea, people in the horse industry in central Kentucky were not impressed. In fact, some even thought that this Boston-transplant might have a couple screws loose.

"We just kept getting rejected, rejected, rejected," said Michael. "I thought it was going to be team effort with people in the horse industry, and we were going to be able to pay for some and get some donated. I had thought I had the perfect plan. But I guess I was the only one who thought that. And I understand now, why. Because they thought I wanted it all for free. They weren't going to go for that."[46]

So, Michael began doing all the work himself, which was always the plan anyway. In that way, he showed everyone that he didn't want anything for free. Still, even while he did so much himself, things were not working out

as he continued looking for a place to start Old Friends. Ever the optimist, he continued to pursue his dream with the utmost certainty that the idea couldn't fail.

His pursuit of the idea went on and on. The days stretched to weeks and then to months, with no success. Then, on a beautiful central Kentucky day, the frustration over his lack of success came to a boiling point. "I had gone down to see my friend Bill Van Den Dool in Midway, who had the Bacchus fine wine store," said Michael. "I was moaning to him about my frustration, and then I said, 'Well, I'm not going to just go around town belly-aching.'"[47]

So, Michael went and picked up a *Daily Racing Form*, sat down on a bench and began to feel sorry for himself. That's when fate intervened: Betty Sue Walters walked by and saw him sitting there with a scowl on his face. She owned an antique store in Midway, and as it turned out, she also owned Afton Farm in Scott County:

> *She asked me, "What's the matter?" I explained my idea and how no one seemed to be interested in helping and then added, "Well, I've got some horses coming in, and I've got no place for them and everything else. There's no…"*
>
> *And, she said, "Well, I've got a farm."*
> *I said, "You do!?"*
> *She said, "Yes. You want to come and look at it?"*
> *I replied, "Yeah!"*
> *So that's the only reason we stayed in Kentucky. Because Betty Sue saw me sitting on a park bench moaning and groaning and acting like a big old baby and screaming out at the world, and she came by and said, "Well, wait a minute, I've got this farm." And that's how we ended up over at Afton Farm.*[48]

So, in February 2003, Old Friends finally had a home at Afton Farm in Scott County, and Michael began to set up his Thoroughbred retirement farm.

The first resident of Old Friends was Michael's horse Invigorate, a gelding that Michael used to train and race. Invigorate, who was sired by Vigors-Astreak, by Green Forest, was a hardworking gelding born on March 27, 1992, in Kentucky. In all, he raced sixty-nine times in claiming and allowance races, won nineteen times and earned $98,327.

Another horse Michael brought to the farm was Rich in Dallas, one of the horses that played Seabiscuit in the 2003 movie. He only stayed a while and then was eventually sent to a farm in Maryland.

The next horse to arrive, and the first official retiree at Old Friends, a farm that was going to cater to stallions, was, ironically, a mare:

> *The first horse we got for the farm was a mare named Narrow Escape. She was left at the February Fasig-Tipton sale. When she didn't get a bid, her owners left her there. So* [the folks at Fasig-Tipton] *called and asked,* "You have a retirement place?"
>
> *I said, "Yeah."*
>
> *They said, "Well, we have a horse they left after the sale. Do you want her?"*
>
> *And I thought, well, we've got to start somewhere, so I said, "Yeah. What's her name?"*
>
> *They said, "Narrow Escape."*
>
> *I said, "Well, that was great. That's a perfect name for our first horse."*[49]

One very important part of Narrow Escape's heritage was that she was a daughter of Exceller, a famous American horse that died in a slaughterhouse overseas. Exceller was a Hall of Fame Thoroughbred famous as the only horse in history to beat two Triple Crown winners in the same race. He beat Affirmed and Seattle Slew in the 1978 Jockey Club Gold Cup. So, to have a daughter of Exceller's in Narrow Escape seemed to be an appropriate start for Old Friends.[50]

With those horses on board, and life at Afton Farm beginning, Michael continued to try to spread the word about the organization. It took a lot of time to get people to really start to listen, and it took a lot of hard work. But for Michael, it was a labor of love.

Then, one day, fate struck again when Michael read an article in *BloodHorse* about the death, by slaughter, of Ferdinand, the 1986 Kentucky Derby winner. With that one article, the history of Old Friends changed forever.

# Chapter 4
# *Ferdinand*

*The 1986 Kentucky Derby Winner and*
*Inspiration for Old Friends*

In the August 9, 2003 issue of *BloodHorse* magazine, Barbara Bayer wrote about the sad demise of Ferdinand, who had been sent to slaughter in Japan. Ferdinand was one of the great Thoroughbreds of all time. His two biggest accomplishments were winning the 1986 Kentucky Derby (G1), which gave his trainer, Charlie Whittingham, his first win in that Classic and gave jockey Bill Shoemaker his final win in the Derby, and winning the 1987 Breeders' Cup Classic (G1) in an exciting victory over 1987 Kentucky Derby winner Alysheba.

In his career, Ferdinand had raced twenty-nine times, won eight times, finished second nine times and third six times and earned $3,777,978.

In addition, he won Eclipse Awards in 1987 as Horse of the Year and Champion Older Male after a stellar season that included four wins, two seconds, one third and $2,185,150 in earnings in ten starts.

After his racing career was over, Ferdinand, who was by Nijinsky (Can)-Banja Luka, by Double Jay, began his stud career in 1995 at Claiborne Farm in Paris, Kentucky. Then, in 1995, he was sent to Japan, where he stood until 2000. After 2000, he was sold again in Japan and, ultimately, was sent to slaughter.

In the story in *BloodHorse*, Bayer mentioned Sunshine Forever, commenting that since his breeding career was over, he might also be in jeopardy. It was the mention of Sunshine Forever in that article that caught the attention of Michael Blowen at Old Friends. He remembered Sunshine and his great run in the Budweiser International (G1) at Laurel Park in 1998—Michael's favorite race of all time.

When Michael read about the fate of Ferdinand in that article, he began thinking about how he could bring horses like Sunshine home to America, where they could live out their lives in peace and dignity at Old Friends.

While returning a horse home to America was a noble idea, accomplishing it was another story entirely. It seemed like an unlikely pipe dream. Who would bring a stallion home from Japan—not to race or breed—but to simply retire?

To start, Michael realized that he would need to work on setting up some type of process with the Japanese horse racing industry so that when a horse was ready to retire from Japan, they would notify Old Friends. Once they set up the process, it could then be used with other countries where there were American Thoroughbred stallions.

Michael began working to set up the system to try to bring horses home from Japan, starting with Sunshine Forever and another horse that was brought to his attention in that article, Criminal Type, another great Thoroughbred champion.

Criminal Type, who was born in 1985 and was a son of Alydar out of Klepto by No Robbery, was one of the great horses that came from Calumet Farm. In his career, he won seven of his eleven starts, six of them stakes races. For his efforts, he took home the 1990 Eclipse Award for Horse of the Year.

As Michael began working to secure the return of the two horses, some problems immediately arose. Michael didn't understand Japanese, and the Japanese didn't understand what he was talking about when he told them he wanted to bring horses home to retire them. They thought that if you're not going to race them or breed them, then what's the point?

Fortunately, Michael found the right person to help him in Emmanuel de Seroux, an international horse buyer and seller. In an interesting twist of fate, it was Emmanuel who had sold Sunshine and Criminal Type to Japan, so he knew where the horses were and, more importantly, had all the contacts.[51]

Soon after Michael began working with Emmanuel, everything started to fall into place, as the Japanese began to understand what he was trying to accomplish. After some more negotiations, they agreed to let him bring the horses home.

With that taken care of, Michael soon discovered that there was one more problem he would need to solve: money! He would need to raise $45,000, which he didn't have, and while fans had contributed a few thousand dollars, he needed a lot more.

Then, once again, fate stepped in, and his mother-in-law, Marguerite White, agreed to cosign a loan for the rest of the money. Two days later, Michael wired the money to Japan to complete the deal.[52] Unfortunately, before he could come home, Criminal Type died in Japan. But while he never was able to come home to the United States, Michael still considered him part of Old Friends and placed a marker in the Old Friends cemetery commemorating Criminal Type as one of the farm's Thoroughbred retirees.

Criminal Type's death, however, opened the door for another Thoroughbred, Creator, to come home, and thanks to Michael's working with Emmanuel, Creator made the trip back to the United States with Sunshine Forever.[53] The symbolic value of the return of Sunshine and Creator cannot be overlooked. Their return gave Old Friends credibility, as up until then, it was just "a goofy idea."

The return of Sunshine and Creator also fulfilled Michael's dream. He believed there were a lot of people out there who loved horse racing and loved these horses the way he did, and they would think that his idea was a good idea and would support it.

Now, every day, people come to visit the horses at Old Friends. There, Michael or one of his staff take them for a walking tour around the farm and introduce them to the horses, and while visitors take pictures, the tour guide tells each horse's story while feeding them some carrots or other treats.

It's fun to watch the horses as they enjoy all of the attention from the visitors, and they preen, pose and perform, bringing smiles and laughter to all. It's hard not to smile once you see the beauty and grace of these great animals.

"All of the years that I was doing the movie critic job at the *Globe*, all those years of interviewing all those movie stars—Jimmy Stewart, Billy Wilder, Jack Nicholson, everybody—I was never as star-struck as I am around these horses," said Michael. "I'm totally star-struck. I just think these horses are incredible. It's just unbelievable. It's like having Larry Bird and Michael Jordan living in my backyard."[54]

# Chapter 5
# Hurstland Farm

While life at the new Old Friends at Afton Farm was an enjoyable start for Michael, he knew that he would outgrow the farm if he was to accomplish his goals of retiring more stallions to the farm. With three horses already on the farm in Narrow Escape, Invigorate and Rich in Dallas; two more Thoroughbreds in Taylor's Special and Ruhlmann on their way; and with Sunshine Forever and Creator coming home from Japan, Michael realized that he was going to need a bigger farm and fast.

With that in mind, and after seeing how long it took him to find Afton Farm, he also didn't have any idea of where to begin looking for a bigger place. So, once again, Michael found himself in Midway talking to his friend Bill Van Den Dool, who today is the vice-president on the Old Friends' board of directors, and trying to figure out what to do. Luckily for Michael, fate stepped in once again, this time in the person of Alfred Nuckols, owner of Hurstland Farm in Midway:

> *We were at Afton Farm with Betty Sue, and we were running out of space. We were bringing stallions home from Japan, and we had stallions already coming to the farm. And Philip, her husband, was trying to run a horse racing operation, and the more horses that we wanted to bring there, the less space he had to carry out his ideas and his directives.*
>
> *So, I was looking for a place, and while talking to* [my friend] *Bill Van Den Dool* [at his store in Midway], *Alfred* [Nuckols] *walked in,*

*and I knew him a little bit, but not really well. We started chatting and I said, "You know, I don't know what to do Alfred."*

*He asked, "Why?"*

*I said, "I've got these stallions that are going to come home from Japan—Creator and Sunshine Forever—and I've got Ruhlmann and Taylor's Special coming to Kentucky too. I've got these horses that need a place, and Betty Sue doesn't have enough room, and her husband, Philip, isn't really keen on the Old Friends idea. I don't know what to do."*

*Alfred said, "Well, come on over. I've got some space and I'll help you out."*

*And that's how we got to Hurstland Farm…I went over, and I looked at Hurstland Farm and thought, "Oh, this is great. It's right here in Midway. The tour busses could get in and out."*

IT ALL SEEMED to work out just perfectly.[55] Michael and Alfred worked out an agreement, and soon after, Old Friends was located at Hurstland Farm.

"You know, Michael's just the kind of guy—it doesn't hurt his feeling if somebody says, 'No,'" said Alfred Nuckols. "He's wonderful about that. I mean, he's been instrumental in getting so much done. Failure has just never been an option. He figures the worse they can always say is 'No' and just move on. And he's done very well with that. He's done a good job."[56]

With his new home base at Hurstland Farm established, Michael began to move horses over to the farm. First, he brought Little Silver Charm, Invigorate and Narrow Escape over from Afton Farm. Then, on November 4, 2004, Sunshine Forever and Creator made their way from New York and arrived at Hurstland Farm. In a November 4, 2004 article by Lenny Shulman for BloodHorse.com, Michael said that both horses were "settling in well," and he thanked "Narvick International and Emmanuel de Seroux for helping facilitate the deals that bought both horses from Japan to Kentucky."[57]

Soon after, in December 2004, Bonnie's Poker, the dam of 1977 Kentucky Derby winner Silver Charm, and Ruhlmann, who captured the 1990 Grade 1 Big 'Cap at Santa Anita, arrived at the farm. Bonnie's Poker was sent to Old Friends courtesy of her owner, Kris Jakeman, while Ruhlmann came to Old Friends thanks to his owners, Jerry and Ann Moss, who would become two of Old Friends' biggest supporters.

With the arrival of horses, a few things began to happen at Old Friends and Hurstland Farm.

First, in addition to stallions, Michael began accepting geldings and mares. Second, Alfred realized that he needed to fence in more paddocks because he foresaw that Michael wasn't going to stop with retiring just a few horses.

Sure, Michael's original intention was to just retire stallions to Old Friends, but things happened and, well, it never was really a rigid rule.

"We were getting requests to take very, very nice geldings, who I remembered," said Michael. "It was basically sentimental. It was basically because I wanted them. Same thing with the mares. Then we got Fraise back from Japan—he was a gelding. Invigorate, my horse, was a gelding. So I wanted to have a place for him. So, while we still focused on the stallions, it wasn't exclusive."

He added, "I mean…we've never been rigid in the way we do things. I didn't want to take mares at first, but our first horse was a mare—Narrow Escape."[58]

Alfred had no problem with Michael bringing in geldings and mares, along with the stallions. But he quickly realized that they would need more space and more paddocks. "When he first started, we were kind of under the impression it was only going to be ten or twelve stallions at most, and they were just going to be all stallions," said Alfred. "It was just going to be kind of a retirement thing to just showcase them because they were really good racehorses.

"Gosh, when Michael got here, I didn't have any paddocks or anything," Alfred continued. "He wanted to set this up, so we went over…and got that going. And we put a new roof on Barn 5 and everything where we were going to showcase the stallions, and we built a bunch of these paddocks behind the office. So that was all done for Old Friends originally. These paddocks are all back behind the office because I didn't have about seven or eight paddocks at that point in time. We figured we'd add some more for those other horses, so I cut off a pasture and put in some paddocks."[59]

"Then, the third big thing that began to happen was what everyone had hoped would happen: tourists began to come to the farm every day to see the horses, some in big tour busses…Old Friends was 'on the map.'"

"I kind of stuck my foot in my mouth [to help get Michael started]," said Alfred with a laugh; at the time, he didn't really know what he was getting himself into. "But, you know, it was really fun…There was a lot of stuff [going on]. Not only were visitors getting to see the retired horses, they were also getting to see a touch of what every day farm life was like and see younger horses all the way up to retired horse. See them from conception to retirement. So that was kind of fun. I really enjoyed that."[60]

In addition to paddocks and office space, Michael also had a gift shop, of sorts. "Hurstland was the home of our first gift shop, which was a card table on the front porch with a bunch of hats on it and a couple things," Michael said.[61]

Michael was thrilled to see people starting to come to Old Friends to visit the horses. He was like a kid at Christmastime as he began to accept more and more horses to the farm as well. "And the tour busses started to come. And the horses started to come," said Michael. "And over that period of time, we brought in some great, great, great, great horses, starting with Sunshine Forever and Creator."

"Ruhlmann was the first Grade 1 winner we ever got sent to us," he continued. "He was our first major star from Jerry and Ann Moss. He was great, great for us. Then we started bringing them home from Japan. I'll never forget when we made arrangements for Creator and Sunshine Forever to come. And when they got off the plane in the middle of the night in New York and then came to the farm, it was wild."

"In the next group, we got Fraise and Ogygian," he noted. "Then Taylor's Special, Bill Mott's first big horse. He won the Blue Grass Stakes in 1984. He put Bill Mott onto the map. Bill Mott owes a lot to this horse. Then Riva Way was one of our first Internet horses. There was a big to-do on the Internet about Riva because he was a son of Tinners Way, out of a Riva Ridge mare. He had Meadow Stable on both sides, as Secretariat was his grandfather."[62]

One other horse that was supposed to come to the farm was Estrapade, one of the great race mares of all time. She had been owned by Michael Paulson, who was the son of Allen Paulson, who raced the mare.

"Estrapade was the only mare to win the Arlington Million," said Michael. "She was tough as nails. I got a call from Hill 'N' Dale saying they want to retire Estrapade to us. I freaked out because she was one of the greatest, toughest mares ever."

Sadly, before she was to be sent over to Old Friends, she died from a heart attack while being loaded into the van for the trip over to the farm. "I told them to please do me a favor. Bring her over anyway, and we'll bury her. And we did."[63] Michael was determined to give Estrapade a dignified memorial service.

In an article on BloodHorse.com from February 25, 2005, Michael said, "She was scheduled to be brought over to us today. We were all hoping that she would have had another couple of years to run around and enjoy herself. We plan to do it up right for her with a headstone and a plaque outlining all of her accomplishments. I'm just sorry that we couldn't give her the same type of life our other retired horses are enjoying."[64]

Alfred also remembered Estrapade and was looking forward to seeing the mare at Hurstland. "Estrapade—she's buried out here," said Alfred, pointing out his office window. "She died before she got here. She was on

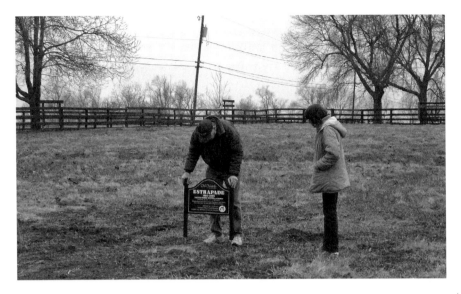

Michael Blowen and his wife, Diane, prepare for the memorial service for Estrapade, the only filly to win the Arlington Million. *Courtesy of Kate Dunn.*

the van, and she fell over dead. We had the stall all bedded down and ready for her and then got a call and was told she dropped dead. She was a lovely race mare. We did bring her over here and buried here entirely. A couple of farmworkers brought a backhoe over, and we dug a great big hole. We gently lowered down her down into it and put a couple bags of lime and sprinkled those around and then just kind of filled it in."[65]

On April 25, 2005, Old Friends held a memorial service at Hurstland farm that many people attended. "Michael had a memorial service for her, and Bucky Sallee [the bugler at Keeneland, who has since retired] came over and played 'Call to the Post,'" said Alfred. "That was really neat."[66]

All of the horses were arriving, and following the memorial service for Estrapade, more and more people began to come and visit the farm. Things began to grow fast. "Michael started off with some fundraisers, and of course, we let this area out here [near where Estrapade is buried] to be a place where he could set up tents and stuff," said Alfred. "We used to have some little fundraisers. He kind of got started with some of that. He just was able to rally people. Like I said, because when he first started going to Keeneland, he'd come around the sales, and try to solicit contributions and everything."

"I can't say enough nice things about Michael," said Alfred. "Michael is just one of the most persistent and the nicest guy you'll ever meet. There's never a bad day. Some days are better than others, but there's never a bad day."[67] Without question, Alfred is very happy about the creation of Old Friends, as well as that it happened in central Kentucky.

"I think it's been the best thing to happen to the industry," said Alfred. "I think it's great that it started in central Kentucky because this is kind of the cradle of the Thoroughbred industry in this area. And the fact that it started here [in central Kentucky], and it's kind of mushroomed out, and it wouldn't surprise me if he didn't have a few more satellite farms down the road."[68]

## Chapter 6

# Old Friends' First Horses at Hurstland Farm

As life for Michael Blowen and Old Friends began at Alfred Nuckol's Hurstland Farm in Midway in the autumn of 2004, things started to move a little bit faster, especially after the arrival of Sunshine Forever and Creator and as plans to bring more horses to the farm began to progress.

Now, all of the horses at Old Friends are beautiful—no question about it. Still, a few do stand out from the others, and one of those is Creator, a big, bold, beautiful chestnut whose dignity and elegance make everyone stop and take notice.

He will almost always come to the fence when a tour heads his way. He will eye everyone carefully and can be a bit nippy, but he also will happily accept carrots, peppermints and other treats. He is especially nice to children.

Today, Creator, who was foaled in 1986 in Great Britain, lives in the paddock directly behind the main house at Old Friends in Georgetown, so Michael's wife, Diane, who is his favorite admirer, can look out the kitchen window and watch him whenever she wants.

"Creator is an amazing athlete," said Michael in a video created by Tim Wilson, who today is the farm manager at Old Friends:

> *One of my favorite stories is* [that] *during the winter, it was very, very cold, and it was very icy. On those days, I have to take an axe and knock the ice off all the waterers.*
>
> *Well, Diane and I finally got to Creator's paddock, and I'm covered in ice. I've got ice all over my glasses, I can't see, I can't get out of my coat because*

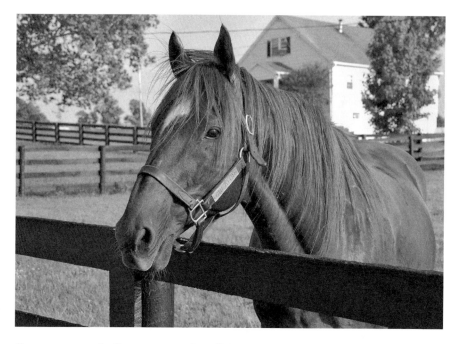

Creator comes to the fence to pose and see if there are some carrots waiting for him. *Courtesy of author.*

*it's frozen, and we pull up to Creator, and the first words out of Diane's mouth are, "I wonder how he's doing. I hope he's okay. It's very, very cold."*

*I joked, "Hey, what about me? I think you like that horse more than you like me." And then, all of a sudden, she started to list everything about why he was preferable to me. Diane said, "Well, Creator is bigger, stronger and more athletic, he's better looking; he's smarter; he made more money; and, he has more hair—a lot more hair!"*[69]

Now, Michael admits that Creator is handsome, as well as bigger and stronger, and he did make more money. But that hair part—as Michael is "hair challenged"—was "really below the belt."

According to Michael, one of the reasons Creator is in the paddock right behind the house is so Diane can always see him. Of course, the opposite is true, too. Creator can see her and watch her cooking and cutting up fruit—one of his favorite treats.

You see, along with carrots, Creator likes strawberries and pears. One year, according to Michael, Old Friends supporter and volunteer Charlene

Brown "sent Creator some expensive pears for Christmas—thirty-five dollars for twelve pears. I got caught once eating one bite out of these pears, and Diane slapped my hand. It was unbelievable but true."

Well, actually, maybe not completely true, as Diane set the record straight: "Creator shared his pears with us, and they were indeed delicious. Michael likes to tell people I prevented him from eating them. Not true."[70]

Creator was born in 1986, the last great son of Mill Reef, out of the Habitat mare, Chalon (Ire). He was a homebred for Sheikh Mohammed. Almost his entire career, 1989 and 1990, Creator raced mostly in France to great success. In addition, he also ran once in England, lost and then traveled to the United States, where he finished third in the 1990 Budweiser International Handicap (G1).

His biggest wins all came in France. In 1989, he won the Ciga Prix Dollar (FR-G2), the Prix Guillaume d'Ornano (FR-G2) and the Prix de Courcelles (Fr). In 1990, he won the Prix Ganay (G1-FR), the Prix d'Harcourt (FR-G2) and the Prix d'Ispahan (G1-FR). According to Michael, his biggest win was the Prix Ganay in 1990. "It is one of the biggest races in all of France, and he won it convincingly," said Michael.[71] Convincingly indeed, as Creator won the race by 4-1/2 lengths over In the Wings, who went on to win the Breeders' Cup Turf (G1) that same year.

Had Creator not been injured in the 1990 Budweiser International in the United States, when he finished third in that race, things just might have been different. "If Creator didn't get hurt in the Budweiser International down at Laurel, there's no question he would have been the favorite in the Breeders' Cup Turf and probably would have won it," said Michael.[72]

Creator finished his career with seven wins, two seconds, three thirds and $555,294 in earnings in sixteen career starts. He was then sent to stand at stud in Japan before being returned to the United States and retirement at Old Friends.

In retirement at Old Friends, Creator has definitely turned into a character. Every once in a while, you will see him running around his paddock in full gallop, maybe reliving his racing days in his own mind. Other days, especially on warm summer or autumn days, visitors will find him lying down, stretched out for a nice afternoon nap.

At other times, while at Hurstland, Michael and Creator would sometimes have afternoon "carrot races," as Alfred Nuckols called them, which were fun to watch. "Creator was a neat horse," said Alfred. "Michael used to have the carrot races out here with Creator. He'd run up and down the fence and race Creator." In the end, Creator would win, of course, and Michael would reward him with carrots and other treats."[73]

—∞—

ABOUT A MONTH after Sunshine Forever and Creator arrived, two other horses arrived at the farm: Ruhlmann, a stakes-winning stallion, and Bonnie's Poker, the dam of 1997 Kentucky Derby and Preakness winner Silver Charm.

Although Ruhlmann is officially registered as a dark-brown/brown Thoroughbred, everyone at Old Friends considered him to be black—Old Friends' "Black Beauty." Ruhlmann was also the first "big name" Grade 1 stakes-winning stallion to be retired to Old Friends, thanks to owners Jerry and Ann Moss, who not only became good friends with Michael and two of Old Friends' biggest supporters over the years ever since—both in horses and in donations—but also helped give Old Friends some much-needed recognition and exposure because of their generosity—this helped Michael in getting donations, and horses, ever since.

At first, Ruhlmann was a little hard to handle. But as Michael had learned over the years, if you treat a horse right, if you allow him or her to be "the boss" and just listen to what he or she is trying to tell you, then, in time, even the most grizzled Thoroughbred will finally allow you to work with him or her. The horse will also learn what "retirement" is all about and will start to relax, settle down and enjoy his or her days on the farm.

Many of the horses become friendly and come over to the fence when they see a tour coming, with the tour guide carrying the familiar red bucket of carrots—they all learn what that red bucket means. Others will come over only when the mood strikes them, and Ruhlmann was one of those.

What Alfred Nuckols enjoyed about Ruhlmann was that he had been foaled at Hurstland Farm in 1985 by Mr. Leader-Indian Maiden, by Chieftain. At the time, Mr. Leader was one of the stallions standing at stud at Hurstland.

"That was kind of fun because Ruhlmann was the son of Mr. Leader [who stood at Hurstland], and he was foaled at Hurstland," said Alfred. "The farm at the time, when it was all together, it was all Hurstland, instead of Hurstland Farm and Nuckols Farm [as it is today]. Mr. Leader was one of the stallions that kind of helped start the farm. So, it was kind of fun to have Ruhlmann back."[74]

In his career, Ruhlmann mostly raced in the United States, but he did race three times in France, with a third place being his best finish.

In 1989, in the United States, under trainer Charlie Whittingham, who was named to the National Museum of Racing Hall of Fame in 1974, Ruhlmann scored wins in the San Bernardino Handicap (G2), the Mervyn

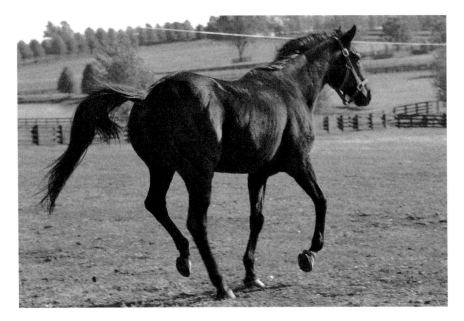

"Run Free Sweet Ruhlmann." This photo was taken a week before the beautiful black stallion passed away. *Courtesy of author.*

Leroy Handicap (G1) and the Native Diver Handicap (G3), while in 1990, he won the Santa Anita Handicap (G1) and repeated in the San Bernardino Handicap (G2).

In 1989, Ruhlmann had a mishap in a race that, in the end, showed just how strong a horse he was, as he was able to come back from it and then win the Santa Anita Handicap. Michael explained:

> *Ruhlmann always liked to take the lead and say, "Come catch me. And, if you can come get me, come get me, and if you can't, see you later." He had one gear; it was like he was in fifth gear all the time. I mean, that was typically his running style. That's how he won the Santa Anita Handicap wire to wire.*
>
> [In a race leading up to the Santa Anita Handicap], *for some reason, he didn't get the lead, and he was a little awkward in this race. For my money,* [jockey] *Ron Hansen gave him* [a bad ride].
>
> *When they're turning for home, there's three horses together. Ruhlmann's now fallen back to third, and obviously, he's done, and Hansen kept going to the whip, going to the whip.*

[Then], *Ruhlmann ducked to the inside, and he clipped heels with the horse in front of him, and when he clipped heels, he fell and somersaulted, went through the fence and knocked down either the eight pole or the sixteenth pole, I'm not sure which. I mean, people thought he was dead. But he got back up, and five months later, he won the Santa Anita Handicap.*[75]

Ruhlmann then came back in 1988 and, under 1995 Hall of Fame trainer Bobby Frankel, won the Jamaica Handicap (G2) and the El Camino Real Derby (G3). All told, Ruhlmann raced twenty-seven times in his career, won ten times, finished second three times, fourth four times and earned $1,824,353. Also, some of his wins were over such notables as Easy Goer and Sunday Silence.

Ruhlmann also had racing a connection with another Old Friends' retiree—Criminal Type, the stallion that didn't make it home from Japan. The two faced each other five times, with Ruhlmann winning twice and Criminal Type three times.

One of Michael's favorite stories to tell about Ruhlmann occurred one winter day after his arrival at Old Friends:

*Ruhlmann, when he raced, raced primarily out in California. When he went to stud, he stood at a farm in California. From there, he went to a farm in south Texas, right near the Rio Grande River. So, when he came to Kentucky, he had never seen snow before.*

*So, that first winter he was here, here was this big, black horse standing in his paddock. Then, a few snowflakes started coming out of the sky, and he started freaking out. He really started going berserk. And I was out there because it was the first snowfall, and I wanted to get some pictures. So he was running around like crazy because he was afraid of snowflakes.*

*Then, very slowly he stopped and looked around. The snow was coming down a little heavier now and starting to accumulate a little bit on the ground. He started to move his neck around like, "This is not too bad."*

*Then he got down and started to roll in it, and he just had a ball. He thought it was the greatest thing. The snow felt so good on his back.*

*It was so neat to see in terms of how excited he was and how beautiful he was, as he was all black and he was rolling in the white snow. Every once in a while, you see these great moments of joy that these horses express, and it truly is amazing.*[76]

Sadly, on December 24, 2006, at Old Friends' home at Dream Chase Farm in Georgetown, Ruhlmann passed away suddenly due to an aneurysm while being walked to the barn for the night.

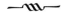

Another horse to arrive at Old Friends in December 2008 was Bonnie's Poker, a 22-year-old mare donated to the farm by her owner, Kris Jakeman. Bonnie was the second mare on the farm, and she and Narrow Escape soon bonded and became inseparable friends.

Bonnie was foaled in Kentucky on March 30, 1982, and was by Poker-What a Surprise, by Wise Margin.

In her racing career, Bonnie raced mostly in claiming races during the 1980s and finished with a record of eleven wins, nine seconds, ten thirds and $153,960 in earnings in sixty-three career starts.

One of her best racing accomplishments was "winning three races in the span of 10 days," according to a BloodHorse.com article. Those races all took place in 1986 at Aqueduct on March 13, 17 and 22.[77] It was one of her offspring, however, that really set her apart from other broodmares, as she foaled 1997 Kentucky Derby and Preakness winner Silver Charm on February 22, 1994.

Bonnie first arrived at Old Friends at Hurstland and then moved to Old Friends in Georgetown, where she lived out her life with Narrow Escape, Cozy Miss and a few other mares in a large ten-acre paddock near the back of the farm until she passed away on August 5, 2010.

"Bonnie was doing very well until the last few weeks," said Michael in a BloodHorse.com article. "Then she started to develop some problems with rear-end mobility. Consulting with Dr. Doug Byars [Old Friends' equine veterinarian], the decision was made to euthanize her before she became dangerous to herself and others."[78]

In an article on the Old Friends website on the day of Bonnie's passing, Michael said:

> *I wouldn't presume to know if a horse's life flashes before their eyes in the moment of death, but I do know that their lives flash before mine.*
>
> *This afternoon, as Bonnie's Poker spent her last breath feeling the pain drift from her 28-year-old body, I remembered the first afternoon in 2004 when I saw her in an enormous field at Nicole Hammond's December Farm in Midway.*

*Bonnie's owner, Kris Jakeman, who nursed Bonnie back after she almost died foaling a Fusaichi Pegasus colt, led me into the pasture. Bonnie wanted nothing to do with either of us. She was a tough old gal. If an actress, she would have played one of Cagney's molls…no-nonsense, tough as nails.*

*She wasn't pretty. But her self-confidence and strong will made her who she was. How many racehorses win three races in 10 days at Aqueduct? Bonnie did.*

*Earlier this summer, at Saratoga, jockey Robbie Davis confirmed what Marianne Haun wrote in her book* The X Factor.

*"She was all heart," Davis said [of Bonnie's Poker]. "One day she was getting tired heading into the stretch and was about to get passed, so I started hitting her. She practically stopped. As soon as I put away the whip, she took off again and won. I wanted to buy her. I wasn't at all surprised that she gave us Silver Charm."*

*Jakeman wasn't surprised either. And when it came time for Bonnie to be retired, Jakeman dug in with the same tenacity as her mare. Bonnie became part of a bankruptcy case, and National City Bank was demanding $25,000 for her. Jakeman, through many letters, begged the court to allow Bonnie to retire. After months of wrangling, Jakeman and Bonnie prevailed.*

*Bonnie won her hard-earned retirement. It's never easy when they go. At least, for us. But, as she gently fell for the last time, she did it without a whimper…dying as she lived.*[79]

—⟋⟋—

In June 2005, Taylor's Special arrived at Old Friends thanks to the efforts of the Washington State–based Hope for Horses, according to Michael. The stallion had been found abandoned in a field in Granite, Washington, and after being identified by a state rescue agency, he was sent to Old Friends.[80]

"I'll never forget Taylor's Special coming in here," said Alfred Nuckols. "That was another one of the first horses we had [here at Old Friends]. He'd been found up in Washington State. I mean, he had just been turned out and been forgotten about. He was living off rainwater and whatever he could forage. And was so emaciated when he got here. How he survived the trip, I don't know. When he got here, he was just skin over a bag of bones."

He continued, "So, we kind of nursed him along and brought him back to health. It took a long time. We couldn't get him on solid food. We couldn't even get him on grain. We had to watch his diet. He was so thin, we had to just watch his diet. He couldn't have too many calories and too much going

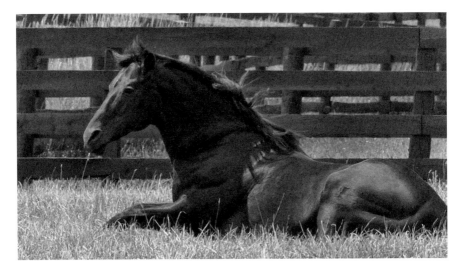

Taylor's Special, one of the most beautiful stallions ever to call Old Friends home, relaxes in his paddock. *Courtesy of Kate Dunn.*

on because we were scared of him getting colic and kill him."[81] But soon he got stronger and enjoyed his life of retirement at Old Friends.

Taylor's Special, who was by Hawkin's Special-Bette's Gold, by Espea, was foaled on April 14, 1981, in Kentucky. He raced for five years and won twenty-one races in forty-one career starts. He also had seven seconds, two thirds and $1,065,805 in earnings.

His biggest wins included, in 1983, the Iroquois Stakes; in 1984, the Black Gold Handicap, the Louisiana Derby (G2) and the Blue Grass Stakes; in 1985, the Count Fleet Sprint Handicap, the Hot Springs Handicap, the Pelleteri Handicap and the Chaucer Cup Handicap; in 1986, the Isaac Murphy Handicap, the River City Stakes, the Louisiana Downs Breeders' Cup Stakes and the Washington Park Handicap (G2); and in 1987, a repeat in the Isaac Murphy Handicap.

In 1985, Taylor's Special also finished in thirteenth place in the Kentucky Derby (G1) and fourth in the Preakness Stakes (G1).

"Taylor's Special was Hall of Fame trainer Bill Mott's first big horse," said Michael. "Taylor's Special won the Blue Grass Stakes in 1984."[82]

Michael has a heartwarming story about Taylor's Special that he enjoys telling about a visitor who came to the farm and turned out to be a special friend of Taylor's Special:

*Many years later, we're at our current location in Georgetown, and a guy comes to the farm. He's probably in his forties, early fifties, and he sees Taylor's Special grazing, and he drops down to his knees and he starts crying.*

*I asked, "What's the matter?"*

*He said, "I didn't know you had Taylor's Special here...For two years, he was my best, and only, friend."*

*I'll always remember what he said. He worked for Bill Mott...It was just unbelievable. Taylor's Special was an unbelievable horse.*[83]

Taylor's Special's time at Old Friends was short, however, and on September 19, 2006, he passed away from a leg injury. In a remembrance of Taylor's Special on the Old Friends' website, Michael said:

*Under a broad Kentucky sky, Taylor's Special died. The great horse with the big ears and a bigger heart can never be replaced.*

*His reputation rests on a staggering 21 wins from 41 starts over five years with 13 stakes wins at nine different tracks under the astute handling of trainer Bill Mott. At 5, he crushed the six furlong record at Arlington Park—a record that, unfortunately, outlasted him.*

*But as great as he was on the track, he was even better as a retiree. At Old Friends, he loved posing for pictures and showing off for visitors, throwing his head back and arching his back, showing everyone that there was still something left in the old bay son of Hawkins Special. Everyone loved him.*

*No matter how much you prepare for the inevitable eventuality, it doesn't make it any less painful when it's time to say goodbye. [Everyone at the farm], in his final moments, [let Taylor's Special know] how much we all loved him.*

*The sun is setting now over the paddocks of Creator and Sunshine Forever and Ogygian and Bull In The Heather, and Precisionist is staring out at Popcorn Deelites and Special Ring. Tomorrow we'll begin preparing for our newest retiree, Awad. Things will eventually get back to normal. But they'll never be the same [without Taylor's Special].*[84]

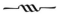

Two other stallions arrived at Old Friends—Fraise and Ogygian—in August 2005. They both got to come back to the United States thanks to Madeline Pickens. She had kindly paid to have both horses returned to the United States and retired to Old Friends.

"She [Mrs. Pickens]…wanted to bring Fraise back," said Alfred. "And Ogygian was over there at the same time, and he was ready to come back… So, she said she would pay for both of those horses. If Fraise is coming, she'd also pick up the tab for Ogygian, which I thought was really nice. Anyway, they both came back…but, unfortunately, Fraise wasn't here for two months, and died from a ruptured aneurysm. He'd been out—he was in a paddock right up [behind the office] and he died."[85]

Fraise was born in January 1988 the son of Strawberry Road (AUS)-Zalataia, by Dictus. In his career, he won ten times in thirty-four starts, with his biggest win coming in the 1992 Breeders' Cup Turf.

When he was done racing, he was sent to stud in Japan. Upon completion of his stud duties, he was gelded and became a riding horse, until he was returned to the Untied States and retired to Old Friends.

Upon his death, "Fraise was cremated, and his remains are buried in the Old Friends Dream Chase Farm cemetery."[86]

# Dream Chase Farm

## Old Friends Gets a Home All Its Own

When you talk to Michael Blowen, the first thing you will immediately realize is that he is always optimistic, always positive, and that there is nothing—nothing—that can't be accomplished if you put your mind to it. No matter what the situation, no matter what the problem, no matter how hard something might be to get it done, Michael will turn around and say something to the effect of, "Here's what we're going to do. It'll be a lot of fun—you'll see." And sure enough, that's the way it all will turn out in the end.

That is the attitude that helped Michael get Old Friends started. That is the attitude that finally landed him at Afton Farm and then at Hurstland Farm. That is the attitude that helped make Old Friends such a successful startup.

So when Old Friends began to outgrow Hurstland Farm, it was that same positive, optimistic attitude that helped Michael finally find a permanent home for the farm. Still, trying to purchase a farm to become the permanent home of Old Friends was definitely one of the hardest challenges Michael had faced up to that point in the early history of Old Friends.

At the start, Alfred Nuckols, owner of Hurstland Farm, where Old Friends was located, joked with Michael about wanting to own his own farm. "Gosh, when he started to buy that farm, I said, 'Michael, believe me, you don't want to buy a farm. You don't know. You don't understand this. Once you own it, it owns you. You don't own the farm, it owns you,'" said Alfred. "And, of course, now he hardly gets off the place. But you know, Michael's

committed his second life to Dream Chase and to the after-care of all these wonderful horses, and it's just so much fun. Old Friends has just been the best thing that's ever happened [to the horse industry], I think."[87]

Michael was determined to find a place for Old Friends to call home, but to start, he was missing the one ingredient needed to purchase a farm: money. But that didn't deter him from finding a way to make it happen. So he came up with a plan, and away he went, full speed ahead, working to make it all happen. Here's the story, according to Michael:

> *We did not have the money to buy this place. We were at Hurstland Farm. Our population was bursting at the seams. Our leasing of price per horse was going up. Our monthly bills, just for leasing that property, was on the verge of $9,000 a month. I thought for $9,000 a month just for leasing the property, we should to be able to buy something so that it will ensure the long-term health and welfare of the horses. This is what we were after in the first place.*
>
> *I used to have these nightmares of something happening at Hurstland Farm, and all of sudden there is no place for these horses. I had this nightmare of all these stallions running down the middle of the street in Midway. It used to drive me nuts.*
>
> *So I started to look around a little bit. I had a friend named Roy Cornett, and he told me about a place for sale over in Midway that was for sale. It was really out of the way and would not have been good for business. It was a very historical farm, which was its main asset.*
>
> *Then we saw Dream Chase Farm in Georgetown, and I knew it would be ideal because it was near the interstate, it was near the Kentucky Horse Park, it had easy access and would be very good for the visitors and there was a lot of room for the horses. There was already a lot of fence here, a house we could use for a bed-and-breakfast and a house we could use for the office.*[88]

Dream Chase Farm is located in Georgetown, Kentucky, on Paynes Depot Road right off I-64 at Exit 69. Georgetown is just northwest of Lexington, Kentucky, in Scott County. The farm consisted of fifty-two acres and had a large main house; a smaller, now-iconic, yellow house at the entrance; and two barns—a large old tobacco barn, which is a familiar sight on many Kentucky farms, and a smaller barn right beside it. It seemed like the perfect fit for a permanent home for Old Friends. Michael continued:

*Now I really wanted to do this, but they wanted almost $1.2 million; I think it was $1,195,000. But I didn't have any money. I didn't know quite what to do, so I went to [my friend] Roy Cornett, and he gave me advice.*

*Roy said, "Why don't you go to Whitaker Bank. They are not a chain bank, and Mr. Whitaker owns the banks and he owns horses."[89]*

*So, I went up to see the bank's president, Jim Calloway, in Georgetown. One of the good things about being in the position of having no money is that you have nothing to lose. You're willing to gamble a little bit, willing to take chances. And you are able to make proposals to people that you wouldn't make if you had a lot of money.*

*I walked into the bank, and I had two green loose-leaf notebooks filled with every check that we ever got in and every check that ever went out. I went to see Mr. Calloway, and I said, "Hi. I'm Michael Blowen from Old Friends. We were named best tourist attraction in Woodford County, and we want to come to Scott County."*

*He said. "Really? What do you want to do?"*

*I said, "I have [to get] $1 million to purchase a farm, and I have no money." And we both laughed. I told him the story of Old Friends and then said, "Well, we need to have this farm, and I can only tell you two things. One, we will never miss a payment, and two, it will be the best loan you have ever made in your life for this bank."[90]*

*I gave him the notebooks that showed the financial picture. "If you run the numbers," I said, "you'll see there is no way you are going to lose money."*

*I then said I had one favor to ask. I said, "I would like Mr. Whitaker to tour at our present facility over at Hurstland Farm. Come see the horses and come see what we are doing. The two of you will either understand it or not."*

*He said, "Okay."*

*I mentioned again, "If you can bring Mr. Whitaker, that would be great. I would really like to show him around."*

*About four or five days later, Jim Calloway and Mr. Whitaker show up at Hurstland Farm. And again, when you have nothing to lose, you just don't care. You are not political, and you are not watching what you say. It all comes out. So, I take them on a tour, showing them the different horses. Jim's nodding, and he and I are chatting and making small talk, while Mr. Whitaker is not saying a thing.*

*We finally get to Taylor Special's paddock, and Taylor, of course, won the Bluegrass Stakes in 1984, and he won the Louisiana Derby the same year.*

*As we got to Taylor's paddock, all of sudden Mr. Whitaker blurted out, "Is that Taylor Special?"*

*I said, "Yes it is sir."*

*Mr. Whitaker said, "That horse cost me millions."*

*I said, "What do you mean?"*

*Mr. Whitaker said, "I had a horse named Fight Over…"*

*Well, now I knew what he was talking about because we show a DVD all the time of Taylor's races, and Fight Over finished second to him once and third to him another time. What that means, of course, is that Taylor's Special became a multiple Grade 1 winner, while Fight Over only scored one graded stakes win in his career—the Grade 3 Aqueduct Handicap—and Taylor's Special was not in that race.*

*When Fight Over went to the stallion breeding shed when his career was over, his stud fee was adjusted accordingly. So, when Mr. Whitaker said, "That horse cost me millions," that's what he meant.*

*So, without missing a beat, I said, "Think of it this way, Mr. Whitaker: if you loan us the money, you will finally own a good horse [in Taylor's Special]."*

*He laughed at that, thank goodness.*

*So, when the tour was over, I handed him the DVD, and he actually gave me a twenty-dollar donation. When I gave him the DVD, I said, "Here you go Mr. Whitaker. Now you can watch your horse get beat over and over again."*

*He laughed again and said to me, "Well, Michael, I'll tell you what. I can't promise you that we will loan you the money, but I can tell you one thing. I'm really used to trying to tell how things can get done and how things can't get done. [I can see] you know how to get things done."*

*Two weeks later, we have the deal, and we're closing on the farm.*[91]

According to Michael, the closing itself was also an interesting affair:

*I had to come up with $150,000 down payment. I had very a good friend in Boston, John Ciccolo. We used to teach together at Emerson College, and when we were both denied tenure, I went into journalism at the* Globe, *and he went into real estate in Boston and made a lot of money. I had a lot of fun but no money. I don't think he had as much fun, but he made a lot of money.*

*I called him up one day and said, "John, I have a big favor to ask of you. I need $150,000. We are going to buy this property, and I need it for the down payment." I promised him that I would pay it back within a year.*

Here's a view of Old Friends from the back of the farm up to the main barn in the upper right. *Courtesy of author.*

*He said, "Okay, fine. When is the closing?" I told him in a week or two. He said, "I'll come down for the closing. We can play a little tennis, we will have some fun and go to the races, and I will give you the money."*

*So, I had that money. Then, when we go to the closing and get the other money, Roy Cornett, who represented us in this transaction, refused to accept any money for his part in working out the deal. And then the woman representing Clay Neel—the seller—wrote us a donation check for $1,000.*

*After the closing was over, I turned to Mr. Calloway and said, "Thanks a lot, Jim. We really pulled this off." Then I asked him, "What made you finally decide you were going to loan us this money?"*

*Jim turned to me and said, "Do you remember that day when I called after you got all the paperwork in, and I asked you a couple questions. Do you remember what the last question I asked you was?"*

*I replied, "No."*

*He said, "I asked you if you would put your house on the line as collateral for the loan, and you did not even hesitate and said, "Yes." At that point, that's when I knew things would work out right.*[92]

So, with the closing done, the dream of Old Friends having its own farm—a permanent home all their own—was fulfilled. Now, to get things started, it was just a matter of moving from Hurstland Farm in Midway to Dream Chase Farm in Georgetown.

And not a moment too soon, as the day after the closing, a Hall of Famer Thoroughbred, Precisionist, arrived at the farm for his retirement.

In 2007, Old Friends had another piece of good luck. The owners of the farm behind Old Friends, the Tuttle family, asked Michael if he'd be interested in purchasing the forty acres at the back of Dream Chase Farm. Michael was interested, a deal was struck for $10,000 per acre ($400,000 total). Old Friends expanded from fifty-two acres to ninety-two acres.

What makes this story so enjoyable, in a way, is that the new forty acres gives Old Friends the proverbial "Back 40" on the farm. So, when a visitor is looking for the Eclipse Award–winning mare Hidden Lake at Old Friends, Michael can turn to them and say, "Oh, Hidden Lake. You can find her in the mare's paddock over the hill in the Back 40."

Another great anecdote to add to the growing list of tales Michael has in his story arsenal. As Michael is fond of saying, "You just can't make this stuff up!"

Chapter 8

# Little Silver Charm

## A Star Is Born

Y ou would think that on a Thoroughbred retirement farm that includes some "big name" stallions, geldings and mares that have won Eclipse Awards, Breeders' Cup races, graded stakes races and one that won a Classic in the Belmont Stakes, one of those "big name" horses would be the star of Old Friends. Well, that's what you would think. But you would be wrong.

The reality is that one little miniature horse rules over Old Friends with an iron hoof—albeit a friendly iron hoof. Interestingly, his origin is unknown. His full pedigree is unknown, although it looks like there might be some Shetland pony in his breeding. And his age his unknown, although a guess might be somewhere in his mid- to late twenties.

What is known is that he has moxie, he is spunky, he is young at heart, he has an attitude, he loves to play soccer and he has a shock of white hair that just might make Hall of Fame trainer Bob Baffert a bit envious. In addition, he keeps up with technology and even has his own Facebook page with 3,872 followers that grows by the day. His name is Little Silver Charm, and he is, without question, the biggest star at Old Friends.

Now, Little Silver Charm should not be confused with 1997 Kentucky Derby winner Silver Charm, although if you could ask the little guy, he would tell you different. He would believe they have the same bloodlines.

Little Silver Charm normally resides in a small round paddock just outside the main barn on the farm. At other times, if his paddock is needed for a bigger horse for rehabilitation or observation, he moves into a larger paddock, which he seems to really enjoy because, as he surely believes

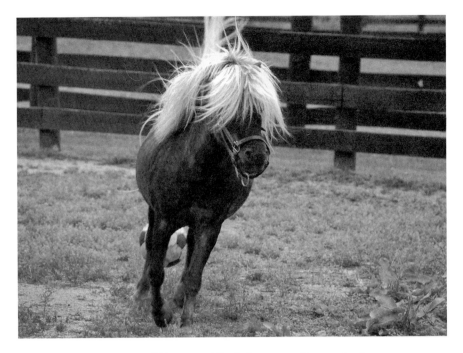

Little Silver Charm shows off his soccer skills during a tour. *Courtesy of author.*

given his stature on the farm, the larger paddock more closely befits his size and "greatness."

You see, Little Silver Charm truly thinks he is just as good a racehorse as any of the Thoroughbreds living at Old Friends. Case in point: on a chilly 2014 February afternoon, while Little Silver Charm's paddock was being worked on and while no one was looking, the little guy slipped out the gate and took a short "personal" tour of the farm. In his travels, he came upon Creator's paddock, and before you knew it, Little Silver Charm and Creator were racing side by side down the paddock lane. The winner…who else but Little Silver Charm?

There's no question that Little Silver Charm has a heart the size of any Thoroughbred at Old Friends and that he believes he is just as powerful, and just as beautiful, as any of them.

The lives of Little Silver Charm and Michael Blowen intersected back when Michael was working at Rockingham in 2001. Michael's friend Lorita Lindemann, who was his trainer at Rockingham, was the person who actually rescued Little Silver Charm off a slaughter truck:

*He was on a truck with some ducks, a goat and, I think, some horses. It was something, I don't know what it is…it was so bizarre.*

*He was sticking his head out, and he was a mess. But the kind of touching part of it was that he had a few tiny little bows left from wherever he was. Possibly some little girl had dressed him up, and the family that had him didn't expect he was going to end up on the killer truck. I mean, he'd been dressed up, and he'd been fixed up, and the guy driving the truck, obviously, wasn't telling the truth when it came to where this little horse was going.*

*Anyway, Lorita liked the little horse so much, she purchased the whole lot of animals for something like forty dollars.*

*So, I show up one day, and there's this horse. And I think, "Oh my God." I took him out and walked him around, and he was mean, and he would pull you all over the place. He was just a nut case. Then, when he got into his stall, he'd go way in the back and hide.*

*He was in such bad shape that even after we cleaned him up, we had to shave everything off. We had to take pretty much all of his tail off, we had to take his mane off, because you just couldn't clean him. It was so awful.*[93]

Michael and Lorita kept Little Silver Charm at the barn for a few weeks, but then the track kept pressuring Lorita to get rid of him because they wanted to use the stall. All of this happened around the time Michael and Diane were getting set to move to Kentucky, so one day Michael just said that since he was taking his horse, Invigorate, to Kentucky, he might as well take the little guy, too, and try to find a place for him to live once he got there.

Originally named Brownie, Michael believed that he didn't look anything like a Brownie. He wasn't even brown in color. In fact, he was a bit gray and he had a beautiful, oversized white mane. So, Michael named him Little Silver Charm in honor of Silver Charm, the 1997 Kentucky Derby winner.

Of course, getting him to Kentucky was another story. According to Michael, when the guy who drove the trailer brought him down to Kentucky, he said, "I'm never going to have one of those little guys on my truck again. He gave me more trouble than any of these Thoroughbreds. What a pain in the ass."[94]

After they arrived in Kentucky, Michael began to really like having Little Silver Charm around, and the little horse became a permanent member of the Blowen household.

When Michael and Diane first moved to Kentucky, they lived in Midway, right near Midway College. The house they lived in had a big fenced-in yard, and that's where Little Silver Charm lived. At times, he would even come into the house, according to Michael:

> *He'd knock on the door when he wanted to come in. He'd come right up on the deck and knock on the door.*
>
> *It was funny* [how it started]. *I was in the house. Previously, I brought him up on the deck. It was three steps up to the deck. So, he knew how to get up to the deck, and it was easy to get up. It was hard for him at first to get down because when he looked down, he couldn't quite figure that out. Going up was fine because he got a good view of that, and he knew he could do that. But going down, he can't quite see what the angles are, and he's not sure where his hoofs would go and stuff like that.*
>
> *Anyway, I was in the living room watching TV, and I see this little face at the door, and all of a sudden I hear* bang, bang, bang… *And I say, "Oh, he walked up there by himself now because he knows there's carrots up here." And I thought, I wonder if he'll come in.*
>
> *So, I just opened the door and went back and sat down. About ten minutes later, he came in, and when he came in, I gave him a carrot. And then he wanted to come in all the time.*
>
> *Carrots are amazing things. They're magic. That's all you need to train a horse is a bunch of carrots. Give me fifty pounds of carrots and a little time, and it'll work out.*[95]

On other days, Michael would put a lead on him and walk him around town. He took him to the bar, and while he had a drink, Little Silver Charm would wait patiently until he was finished. Michael also took him to Bill's Van Den Dool's wine shop, or he'd walk him up to the drive-through window at the bank. Little Silver Charm was even in the Midway Parade one year. It seemed that everyone in town loved the little guy. Well, everyone except one person.

"There was one really ornery guy a couple of blocks away from where we lived," said Michael. "I found out subsequently that he was mad because they wouldn't let him have chickens in his yard, and his feeling was, 'If I can't have chickens in my yard, that bastard from New England is not going to be able to have that damn little horse in his yard either.' So, the guy brought this up to planning and zoning to try and have Little Silver Charm removed from my property."[96]

Well, that poor guy had no idea who he was dealing with in Michael, or how beloved Little Silver Charm was to the community:

*Now, I really took this seriously. It's funny now, but I was nervous that they were going to make me get rid of him. I just moved here. I didn't know what the deal was.*

*So, I decided I'd have a campaign and create a petition to keep Little Silver Charm in my yard. Penny Chenery, who owned Secretariat, became part of the campaign. She was on our poster. I've got a picture of Penny with him with this bemused expression on her face.*

*We started campaigning. We got all these people in town to sign the petition. All my immediate neighbors signed the petition—all of them did—so we could be armed to go to planning and zoning.*

*In fact, I believe that more people signed the petition to keep Little Silver Charm in the neighborhood than voted for mayor—on both sides—collectively.*

*Then there was this guy on Channel 27 who did features, and he came out one rainy morning and he did this whole story about Little Silver Charm. The feature talked about this "one mean neighbor who wants to get rid of Little Silver Charm." And he showed the petition; he had people in downtown Midway talking about how much the horse meant to the town. I mean, it was hilarious. You know, from his humble beginnings, Little Silver Charm had become this star down there.*

*Meanwhile, when I'd go to the Midway Market, they wouldn't ask me about anything...how I was doing, how Diane was doing. Instead, they'd immediately ask, "How's Little Silver Charm?" They even had pictures of him up.*

*Needless to say, planning and zoning passed an ordinance that declared Little Silver Charm was a pet, and that ended it. I actually have official documentation that reads something like... "Whereas, Little Silver Charm has never bred another horse, whereas he's not going to be raced, whereas he's not doing things for money, this, that and the other...all these things whereas, we finally declare he's a pet." It's hilarious. It's really funny.*[97]

When Michael and Diane moved Old Friends to Dream Chase Farm, the small paddock next to the barn was already there, and that's where Little Silver Charm soon called home. The paddock was originally built for broodmares, but Little Silver Charm settled right in. It was a perfect size for him, and according to Michael, since miniature horse can founder easily, it was easier to control his eating in the smaller round paddock as well.

Unfortunately, the paddock did not have a run-in shed for Little Silver Charm, but that was soon fixed. "All the other big horses have their run-in sheds, all done by the Amish," said Michael. "Well, the Midway Eagle Scouts came through on a tour one day, and they decided that Little Silver Charm needed his own place. So, they built him a run-in shed, and as a result, Little Silver Charm had one of the best ones on the place. It's totally his. 'No pre-fab for me,' says Silver Charm. 'I want the big house.'"[98]

While tours at Old Friends take different routes around the farm, eventually they always pass by Little Silver Charm's paddock. One of the fun things that Michael does during a tour with Little Silver Charm is play some soccer. You see, a long time ago, Michael kicked a soccer ball toward Little Silver Charm, who promptly turned around and kicked it back with his back feet. Ever since, the two of them have shown that trick off to tourists when they visit.

Another fun thing Michael does with Little Silver Charm is get the little guy to give him a kiss for a carrot. Michael will bend over, and Little Silver Charm will give him a nice wet lick across the face. The result, after Michael wipes his face, is that the little guy gets some carrots.

About the time the run-in shed was completed, Little Silver Charm was starting to become one of the biggest hits on the tour. People come to Old Friends to see the great Thoroughbreds, but before they leave, they are all also talking about Little Silver Charm.

Over time, Little Silver Charm has earned many, many fans from all over. For example, one day Michael received a whole parcel full of notes from second graders in Corbin, Kentucky, talking about how much they loved Old Friends...but how they especially loved Little Silver Charm.

"You never know when it's going to turn up," said Michael. "I mean, we've had kids that come with their school programs during the week, and then on the weekends they demand that their parents take them back to see this little horse."[99]

Shares in Little Silver Charm also are one of the best sellers in the gift shop. "We sell shares in all the horses to raise money, and it's $100—except for him, it's $25," said Michael. "And that's in direct contributions."[100]

Little Silver Charm has also seen his face appear in many other places over the years, including on a wine bottle that was drawn by Michael's friend Jack Nicholson.

However, Little Silver Charm's biggest claim to fame came when *People* magazine came to do a feature about Old Friends. The article ended up in the August 18, 2008 issue of the magazine—the one with Brad Pitt and

Angelina Jolie on the cover with their newborn twins. In the three-page article, there were three photos: a photo of Michael with Popcorn Deelites and Special Ring; a photo of Eight Belles, the filly who died after finishing second in the 2008 Kentucky Derby; and a photo of Michael and Diane with—who else—Little Silver Charm. With that issue, Little Silver Charm's stature and public image began to grow in leaps and bounds.

"The people at *People* magazine told me that Little Silver Charm got more letters than the story about Angelina Jolie's babies," said Michael.[101]

AS THE SUN SETS on another cold winter day in Kentucky in January 2014, Michael walks out of his garage with a handful of carrots and heads over to Little Silver Charm's paddock. The little guy sees Michael coming and walks over to greet him. Michael hands his buddy a few carrots through the fence, which Little Silver Charm happily takes and munches away on. The two friends have traveled a long road together, but now they get to quietly relax and enjoy each other's company whenever they want at Old Friends.

## Chapter 9

# The Champions

Old Friends has had many Thoroughbred retirees over the years, and each one of them is wonderful in his or her own way. Many of them won some big stakes races during their racing careers, some were just hardworking racehorses that needed a final place to call home and a few were even rescued from some precarious situations.

The one thing Old Friends has never had is a Kentucky Derby winner, but as Old Friends continues to grow in honor and prestige, that may finally happen. Still, while Old Friends might not have had a Derby winner yet, the farm has had six Eclipse Award winners and one Classic winner. These include Eclipse Award winners Sunshine Forever, 1988 Male Turf Champion and Michael's all-time favorite horse; Gulch, 1988 Male Champion Sprinter; The Wicked North, 1994 Champion Older Horse; Hidden Lake, 1997 Champion Older Mare; Black Tie Affair, 1991 Horse of the Year and 1991 Champion Older Horse; Precisionist, 1985 Eclipse Champion Male Sprinter; and Classic champion Sarava, winner of the 2002 Belmont Stakes.

You've already read Sunshine Forever's story. Here are the stories of the other Thoroughbred champions who call, or have called, Old Friends home.

———ഗ———

GULCH WAS FOALED in Kentucky on April 16, 1984. He was sired by Mr. Prospector, out of the Rambunctious mare, Jameela. During his racing career, he won thirteen times and earned $3,095,521 in thirty-two career

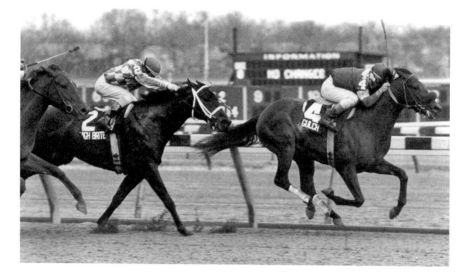

Gulch winning the Bay Shore Stakes in 1987 at Aqueduct. *Courtesy of Bob Coglianese Photos; appeared in* BloodHorse *magazine.*

starts between 1986 and 1988. The biggest win of his career was the Breeders' Cup Sprint Stakes (G1) at Churchill Downs, which he won in exciting fashion, running against another Old Friends retiree, Precisionist.

"In the 1988 Breeders' Cup Sprint (G1), Gulch and Precisionist stalked side by side, with Canadian champion Play the King outside them. Down the final stretch Gulch and Play the King surged forward, fighting it out furiously. Responding gamely to Angel Cordero's urging, Gulch pushed ahead to the wire."[102] With the Breeders' Cup Sprint and his other victories in 1988, Gulch won the Eclipse Award as Champion Sprinter.

Upon retirement from his racing career, Gulch stood at William Farish's Lane's End Farm in Versailles, Kentucky, until 2009, when he was pensioned. Then, through Mr. Farish's generosity, he was sent to Old Friends. How that came about is an interesting story that Michael enjoys telling:

> *When Lane's End announced that Gulch was going to be retired, I called over there and said, "Look, we'd really love to have Gulch at the farm. He's a star. He'd have a lot of fans. I know you're going to take great care of him," said Michael. "But, you're a breeding operation and we're a tourist operation and we could cater to his needs and his fan's needs and we'd just adore having him. I love the horse."*

*I didn't hear anything for two week from Lane's End, and then I get a call from Bill Sellers. Bill is the stallion manager at Lane's End. He says, "Can I come over and look at your farm? I know you put in a request for Gulch, and I'd just like to have a look around. Can I come over?"*

*I said, "Yes, please come over." So, later that afternoon, here comes Bill Sellers.*

*Now, he couldn't have picked a worse day to look at Old Friends. It was muddy. The Lexington Shoeing School was supposed to come and do all of our trims, but they were delayed by the weather. So the horses were still days away from doing their trims, and their feet looked bad. The horses were all muddy. It was a crummy day. The whole circumstances could not have been worse. Because of all this, I had no doubt that there was no way in the world that Mr. Farish was going to allow Gulch to be retired to Old Friends.*

*So, later that afternoon, here comes Bill Sellers, and we hop on the golf cart and drive around. I'm going through the tour and telling him about the horses we have and where Gulch would be, and where he'd have his paddock and all of this. And, I'm thinking, "There's no way that they're ever going to send Gulch to Old Friends."*

*We get done with the tour. Bill's wet from the rain. And he says, "I'm going to go back and recommend to Mr. Farish that they send Gulch to Old Friends." And I said, without being the least disingenuous, "Why?"*

*He said, "Well, I'll tell you what. We picked him up the night that he won the Breeders' Cup Sprint at Churchill Downs, and we brought him to Lane's End, and from that time 'til now, he hasn't had a spot of mud on him. I really think he deserves to have some mud on him, so I'm going to recommend to Mr. Farish that he send Gulch to Old Friends."*

*A few days later [in December 2009], here comes Gulch on the Lane's End truck. Steve, the guy who took care of him all those years at Lane's End, led him off the trailer, and as they say, the rest is history.*[103]

THE WICKED NORTH came to Old Friends in October 2008 and became a favorite of longtime Old Friends volunteer Tim Ford.

Tim enjoyed spending time with the big, beautiful chestnut stallion and even spent hours learning how to groom him. The two could be seen in a stall on many Sundays, with Tim brushing and grooming and making The Wicked North look as beautiful as ever.

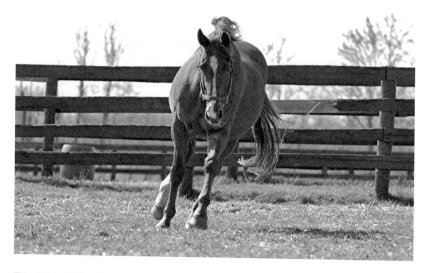

The Wicked North, the Eclipse Award–winning Older Male Champion in 1994, enjoyed running around his paddock. *Courtesy of author.*

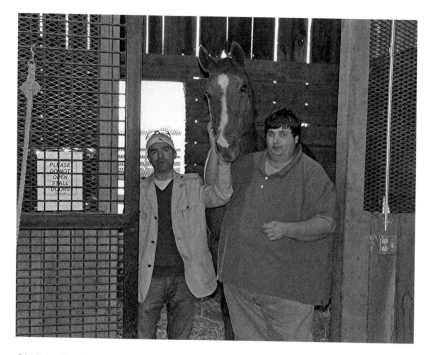

Old Friends volunteer Tim Ford (right) and jockey Kent Desormeaux pose with The Wicked North. *Courtesy of author.*

What was funny, even to Tim after a while, is that after he did all that work, he would let The Wicked North out in his paddock. "Wicked," as Tim called him, would, calm as could be, find the dirtiest spot in the paddock, get down and roll to his heart's content. He'd then get up, shake off all the dirt he just got on him and then go out and graze the rest of the day away.

The Wicked North was born in Kentucky on May 25, 1989, the son of Fleur-Wicked Witchcraft, by Good Behaving. In his career, he raced between 1991 and 1994, won eight times and earned $1,180,750 in seventeen career starts.

As a 5-year-old in 1994, he had the best year of his career, as he won the San Antonio Handicap (G2) at Santa Anita; the California Stakes (G1) at Hollywood Park, where he set a track record for 1-1/8 mile; and the Oaklawn Handicap (G1) at Oaklawn Park.

However, in a controversial finish to this day, The Wicked North, with jockey Kent Desormeaux riding, crossed the finish line first in the Santa Anita Handicap (G1) yet received a disqualification for drifting into the path of another horse.

"I was disqualified from one of the easiest wins I've ever ridden," said Desormeaux, a longtime supporter of Old Friends who visits the farm from time to time. "That horse had awesome confirmation. His character was to love his racing."[104] However, even with that controversial finish, The Wicked North's three wins that year, two of them Grade 1s, earned him the 1994 Eclipse Award as Champion Older Horse.

Upon his retirement from 1995 to 2006, The Wicked North stood at stud in California, New York and in Kentucky at True North Farm in Versailles. Over time, The Wicked North battled EPM and colic, which eventually ended his stud career. He was retired to Old Friends in October 2008 by former Michigan racing commissioner Annette Bacola.[105]

The Wicked North enjoyed his retirement, spending his days grazing in one of the front paddocks. But then, three years later, on March 29, 2011, he fell ill and was humanely euthanized at Hagyard's Equine Medical in Lexington after suffering with a fatal lipoma.[106]

HIDDEN LAKE, a beautiful bay, graces the mare paddock on the Back 40 at Old Friends. When she first arrived, she joined a herd that included Old Friends' three grande dams: Narrow Escape, Bonnie's Poker and Cozy Miss.

Hidden Lake fit in perfectly with those three, as she does today with her current herd of mares. A proud mare, Hidden Lake socializes if necessary,

Hidden Lake, a favorite of volunteer Barbara Fossum, walks around her paddock on a beautiful Kentucky morning. *Courtesy of author.*

but most of the time, she is happily self-sufficient, grazing near the other mares but always keeping an eye on things.

Of course, that doesn't mean she won't stand up for herself if she needs to at times. If one of the other mares gets out of line or tries to encroach in her space, Hidden Lake will promptly let the other mare know who's in charge. That's Hidden Lake—quiet, proud and tough as nails.

Hidden Lake was born at Nuckol's Farm in Midway on April 2, 1993. Nuckol's Farm is run by Charles Nuckols III, who is a big supporter of Old Friends and currently (in 2014), boards about twenty of Old Friends' retirees at his farm.

Hidden Lake raced twenty-two times between 1995 and 1997, won seven races and earned $947,489.[107]

When Michael told longtime Old Friends volunteer Barbara Fossum that Hidden Lake was coming to the farm, she was ecstatic because she had been a big fan of the mare her entire career. She even brought a scrapbook into the office that she had put together over the years to show Michael and the rest of the staff. It contained numerous photos, articles and other things about Hidden Lake.

To this day, if you go back to see the mares on a late Saturday afternoon, there is a good chance you will find Barbara out in the paddock with Hidden

Lake, spending time with her and grooming her. If you watch for a while, you can tell the two enjoy their time together. If you want to know the complete story about Hidden Lake, just ask Barbara. She will tell you about her favorite race mare of all time:

*She knows who she is. She knows what she has accomplished. She is everything a great horse should be. She is Hidden Lake.*

*Hidden Lake was a 1994 Keeneland September $13,000 yearling purchase by Weir Stables [Dennis and Jim Weir]. She won her first race for the Weirs and trainer Walter Greenman, taking a Del Mar maiden race on August 5, 1995, and would go on to take the Grade 2 La Brea Stakes at Santa Anita late in her 3-year-old year.*

*In the spring of 1997, Hidden Lake was purchased privately by the partnership of Robert Clay and Tracy Farmer. Trainer Greenman recommended transferring her to New York, feeling that the hard tracks in California were stinging her feet. Hidden Lake was subsequently transferred to the stable of New York–based trainer John Kimmel, an equine veterinarian in addition to being a top trainer.*

*Doubtless contributing to what would be Hidden Lake's success in 1997 was the realization by Kimmel soon after Hidden Lake arrived in his barn that her hind area was somewhat weak and that she had an arthritic condition. Kimmel employed a number of alternative therapies to treat Hidden Lake, including chiropractic care, magnetic boots and a magnetic blanket and acupuncture treatments.*

*The move to New York and Kimmel's care proved popular with Hidden Lake. She won her first start at Belmont Park, the Grade 2 Shuvee Handicap, which marked the first time that the rapidly improving Hidden Lake would be paired with jockey Richard Migliore, who labeled her current form "scary."*

*Next up for Hidden Lake was the Grade 1 Hempstead Handicap, also run at Belmont Park. Called one of the strongest distaff fields assembled that year, Hidden Lake sat just behind rapid fractions before taking over at the head of the stretch and lengthening her stride to win by two lengths. After the race, Kimmel said, "Hidden Lake is one of the horses that they're going to have to deal with down the road for honors in this division."*

*In every champion's season, there is a defining moment. For Hidden Lake, that moment came on July 27, 1997, at the legendary Saratoga Race Course in upstate New York. In fine form and sporting a two-race winning streak, Hidden Lake entered the starting gate for the Grade 1 Go*

*for Wand Stakes as favorite against six foes, including her stablemate Flat Fleet Feet.*

*Hidden Lake led through moderate early fractions, with Flat Fleet Feet racing in close attendance. As the two fillies came around the final turn, what was referred to as the most exciting twenty-five seconds of the meet unfolded, with Flat Fleet Feet surging ahead of Hidden Lake as the two fillies entered the stretch.*

*Hidden Lake fought back, regaining the lead briefly before losing it again one hundred yards from the finish line. But Hidden Lake wasn't done. She fought on courageously, and with track announcer Tom Durkin relaying, "What a brave filly, she's coming back!" Hidden Lake defined herself as a worthy champion, digging deep to find the energy to give a final lunge toward the finish line to win by a gutsy head.*

*After the race, Migliore said that Hidden Lake "reached down and found something that wasn't there" to gain the victory.*

*The excitement of Hidden Lake's victory was tempered somewhat when Migliore felt her wobble as she was pulling up after the race. Subsequently, Hidden Lake was diagnosed with heat prostration, as temperatures in the nineties, high humidity and a grueling race took their toll. She was immediately hosed down but was unable to return to the winners' circle. Those who witnessed Hidden Lake's defining race came away from Saratoga that day knowing they had indeed seen something very special.*

*Now placed firmly at the head of her division, Hidden Lake returned to her favorite track, Belmont Park. After a ten-week layoff to recover from the lingering effects of her remarkable performance at Saratoga, she raced to an authoritative victory in the Grade 1 Beldame Stakes. Migliore said of his partner after the race, "Absolutely, hands-down, this was her easiest win since I've ridden her. At the three-eighths, she was going so easily it was almost scary. I had the field at my mercy any time."*

*Hidden Lake returned to California to run in the Breeders' Cup Distaff late in the year. She failed to duplicate her New York form, with Kimmel attributing her poor performance to the hardness of the Hollywood Park track, saying, "I think she knew that track was too hard for her and she was protecting herself."*

*Hidden Lake retired from racing with seven wins and earnings over $940,000. She was the runaway winner of the 1997 Eclipse Award as Champion Older Female.*

*In the breeding shed, as is the case with so many champion race mares, she failed to produce offspring with her talent and speed. Hidden Lake was*

*retired to Old Friends through the generosity of her owner, Robert Evans, with the assistance of Taylor Made Farm in January 2009.*

*Many factors contributed to what would become Hidden Lake's championship season. Trainer Greenman's unselfishness in recommending she relocate to the East Coast, effectively removing a potential champion from his barn. Owners Clay and Farmer for heeding Greenman's advice and placing her in the care of a trainer with the veterinary skills to effectively manage Hidden Lake's health issues. The teaming of Hidden Lake with Richard Migliore was the perfect pairing of a horse and jockey who brought out the best in each other.*

*And then there is Hidden Lake herself. Here is a mare with uncommon courage, determination and bravery. Today's Hidden Lake still carries those same championship traits, albeit somewhat tempered with time. Not fond of crowds, she rules the Old Friends band of mares with a firm but somewhat distant touch. How many times, asleep in the night, does she dream of the racetrack? Perhaps she relives her victories, hears again the cheer of the crowd, stretches to reach the finish line one final time.*

*She is all heart. She is an Eclipse Champion, and she knows it. She is Hidden Lake.*[108]

BLACK TIE AFFAIR (Ire) was born in Ireland on April 1, 1986, the son of Miswaki-Hat Tab Girl, by Al Hattab, but he spent his racing career in the United States.

A big, beautiful gray stallion, who turned white as he grew older, he was trained by Ernie Poulos and raced between 1988 and 1991. In total, he raced forty-five times and had eighteen wins and $3,370,694 in earnings.[109]

His best season came in 1991, as a 5-year-old, when he won six graded stakes races in a row, including the Philip H. Iselin Handicap (G1) at Monmouth, the Washington Park Handicap (G2) at Aqueduct, the Commonwealth Breeders Cup Stakes (G3) at Keeneland, the Cornhusker Handicap (G3) at Ak-Sar-Ben, the Stephen Foster Handicap (G3) at Churchill Downs and the Michigan Mile & One Eighth Handicap (G2) at Detroit Race Course.

Black Tie Affair capped that season with a gate-to-wire win in the Breeders' Cup Classic (G1) at Churchill Down that earned him Eclipse Awards as Champion Older Horse and, most important of all, 1991 Horse of the Year.

Upon retirement from racing, Black Tie Affair stood at Ben Walden Jr.'s Vinery near Midway, Kentucky, in 1992, and then in 1997, he was sent

to Japan for several years for breeding. During his stud career, Black Tie Affair sired such greats as Evening Attire (Jockey Club Gold Cup), Formal Gold (Woodward S), Washington Color ($3 million in Japan), License Fee (millionaire) and some thirty other stakes winners.[110]

After returning to the United States from Japan in 2004, the stallion stood at Randy Funkhouser's O'Sullivan Farms near Charles Town, West Virginia, for a partnership managed by Donna Hayes. In 2009, thanks to owner Delores "Dee" Hopkins-Poulos, who took over training duties after her husband, trainer Ernie Poulos, passed away, Black Tie Affair was sent to Old Friends due to arthritis.

Said Poulos:

> *I first heard about Old Friends through reading* BloodHorse *magazine and other industry publications. However, I really became aware of the scope of the facility when Donna Hayes of White Post, West Virginia, the woman who was in charge of the Black Tie Affair breeding syndicate, contacted me to say that Black Tie was suffering some terrible health issues and would probably need to be retired.*
>
> *I checked with some farms in the Chicago area; however, they were really not equipped to take on a retired Black Tie, even though he was a local hero. She then called, and we discussed the possibility of sending him to Old Friends, and it all seemed like a very positive move for him.*
>
> *Upon Black Tie's arrival at Old Friends, I spoke to Michael for the first time and found him to be so kind and engaging. His excitement over having Black Tie at his facility was so heart-warming. I had such a sense of it being absolutely the "right thing" when I got off the phone. Also, in addition, I was really pleased that Black Tie would be closer to our location, and we could visit him.[111]*

There was no question that Black Tie Affair was an important part of Dee Poulos's life. "He was just life-changing for us," she said. "It was such a wonderful experience with him. He was, and will still be, an inspiration for me. When things got tough, I would think about Black Tie. He was my motivator."[112] One of Dee's favorite stories about Black Tie was one, she believes, showed his intelligence:

> *During his racing career, Black Tie was not a horse that liked to interact with people; he was not a peppermint horse. [However], he loved his groom, Ruben, who still works for me as my assistant.*

*Ruben traveled with him all the thousands of miles that were necessary during his 1990 and 1991 campaign. Black Tie was so used to getting on a van to go race that he would lie down in his box stall before they were out the stable gate.*

*When Black Tie raced in the Washington Park Handicap at Arlington Park, his last race before the Breeders' Cup Classic, he was unwilling to go to the paddock. Ernie thought he was going to have to haul him in the van first!*

*However, Ruben took him out of his stall and led him around the backstretch before going to the paddock. Obviously it made Black Tie happy for he won by many [lengths] on a very muddy surface.*

*After winning the "Classic," Black Tie returned to our barn at Sportsman's Park* [not in existence anymore]. *Hawthorne Park was having their fall/winter meet and they wanted to honor Black Tie and have his farewell a public event.*

*A huge crowd turned out to see him paraded. Several were dressed in tuxedos to commemorate the wonderful success of the "blue collar" horse from Chicago. It was a cold, snowy December day; however, it did not stop the crowd from moving on to the apron to get a close-up look at their champion.*

*I can still see a lone figure dressed in a tuxedo, leaning on a black cane with a silver horse's head as a handle, with tears in his eyes as he watched from the winner's circle—that figure was Ernie Poulos.*

*After Black Tie had strutted his stuff, he was to come into the winner's circle for a photo session. However, that was when he "put on the brakes" and did not want to go to his position. He figured that he hadn't raced; therefore, why would he be in the winner's circle!*

*I have that photo on my office wall, and there he is with his front legs propped and Ruben is doing his best to get him in the photo.*[113]

In June 2010, Dee Poulos made a trip from her home in Chicago to see her champion at Old Friends. "I felt I just had to see him, and I told my sister that we just had to go," said Poulos, "and I'm so glad we did. I spent a lot of time with him that day. We brought him out, and he was just grazing, and I was playing with his ears—I always loved the feel of his ears—and he suddenly looked up at me, and I thought, 'Oh, Black Tie just said goodbye.' I didn't want to think that way, but it was a terrible feeling I had."[114]

Poulos's thoughts, and timing, were all too sadly correct. On July 1, 2010, Black Tie Affair was humanely euthanized due to laminitis at age 24. He

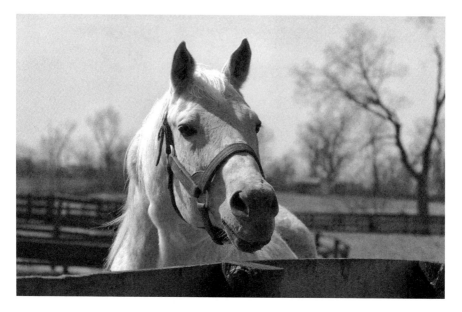

Black Tie Affair, the 1991 Horse of the Year, was one of Michael Blowen's favorite horses at Old Friends. *Courtesy of author.*

had also been suffering from cancer. Michael and Dr. Doug Byars made the decision in the morning to end his suffering.

"It was an honor to be associated with such an amazing athlete," said Michael of Black Tie Affair, a horse he had become very close to in the short time he was at the farm. "The Old Friends team, headed by Dr. Byars, did everything we could to help this old warrior. In the end, he exhibited the same class as he did when he won the Breeders' Cup Classic. He was the best in every way."[115]

PRECISIONIST WAS BORN on February 28, 1981, in Florida; his owner and breeder was Fred Hooper. A beautiful chestnut, he was sired by Crozier, out of the Forli mare Excellently. In his racing career between 1983 and 1988, Precisionist won twenty races and earned $3,485,398 in forty-six career starts. He was trained by Ross Fenstermaker.

His best year was 1985 as a 4-year-old, when he won four Grade 1 stakes races, including the Mervyn Leroy Handicap (G2) at Hollywood Park, the Charles H. Strub Stakes (G1) at Saratoga and the San Fernando Stakes (G1)

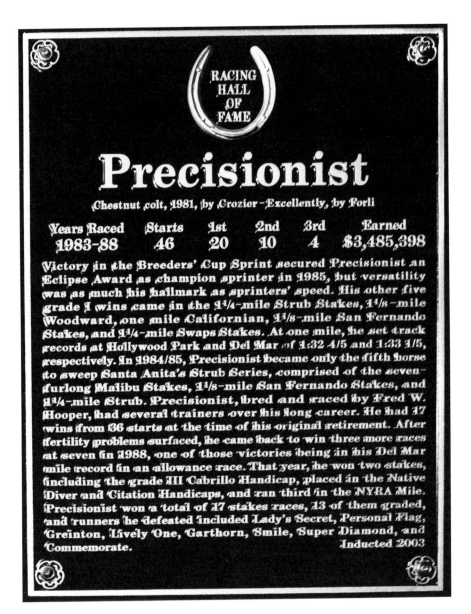

## RACING HALL OF FAME

# Precisionist

Chestnut colt, 1981, by Crozier – Excellently, by Forli

| Years Raced | Starts | 1st | 2nd | 3rd | Earned |
|---|---|---|---|---|---|
| 1983–88 | 46 | 20 | 10 | 4 | $3,485,398 |

Victory in the Breeders' Cup Sprint secured Precisionist an Eclipse Award as champion sprinter in 1985, but versatility was as much his hallmark as sprinters' speed. His other five grade I wins came in the 1¼-mile Strub Stakes, 1⅛-mile Woodward, one mile Californian, 1⅛-mile San Fernando Stakes, and 1¼-mile Swaps Stakes. At one mile, he set track records at Hollywood Park and Del Mar of 1:32 4/5 and 1:33 1/5, respectively. In 1984/85, Precisionist became only the fifth horse to sweep Santa Anita's Strub Series, comprised of the seven-furlong Malibu Stakes, 1⅛-mile San Fernando Stakes, and 1¼-mile Strub. Precisionist, bred and raced by Fred W. Hooper, had several trainers over his long career. He had 17 wins from 36 starts at the time of his original retirement. After fertility problems surfaced, he came back to win three more races at seven in 1988, one of those victories being in his Del Mar mile record in an allowance race. That year, he won two stakes, including the grade III Cabrillo Handicap, placed in the Native Diver and Citation Handicaps, and ran third in the NYRA Mile. Precisionist won a total of 17 stakes races, 13 of them graded, and runners he defeated included Lady's Secret, Personal Flag, Greinton, Lively One, Garthorn, Smile, Super Diamond, and Commemorate.                                    Inducted 2003

Precisionist's Hall of Fame plaque hangs at the National Museum of Racing and Hall of Fame in Saratoga, New York. *Courtesy of Brian Bouyea/HOF Communications Coordinator.*

at Santa Anita. He finished the year with the most important win of his career: the Breeders' Cup Sprint Stakes (G1) at Aqueduct, which catapulted him to the Eclipse Award as Champion Sprinter.

Following his 1986 campaign, in which he had wins in five graded stakes, including the Grade 1 Woodford Stake at Hollywood Park and two Grade 2s, the San Bernardino Handicap and San Pasqual Handicap at Santa Anita, he was retired.

As a sire, he wasn't as good as he was on the track, so he returned to racing. In 1988, as an 8-year-old, he won the Del Mar Breeders' Cup Handicap and the Cabrillo Handicap (G3), both at Del Mar. Then, following his 1988 campaign, he was retired for good. Eighteen years later, in 2003, Precisionist was inducted into the Racing Hall of Fame.[116]

Following Hooper's death, the stallion was cared for by veterinarian Siobhan Ellison in Fairfield, Florida, and in the spring of 2006, she donated Precisionist to Old Friends. Precisionist's time at Old Friends was all too short, however, as he suffered from a number of ailments. Sadly, just a few months after he arrived, on September 29, 2006, he was euthanized due to a tumor in his sinus cavity.[117]

In a tribute article following his passing, Michael wrote the following about the beautiful stallion he had grown so fond of in such a short time:

*As great as he was as a racehorse, it can't compare with his other qualities—intelligence, patience, stoicism and bearing. On Wednesday afternoon, his final day, he proved he didn't leave his class on the racetrack. He held his head high and didn't whinny once as he led us from his stall to the gravesite. He stopped once to nibble at the grass and gaze over at Bonnie's Poker and Narrow Escape. He knew it was his time, and he did everything in his power to make this most painful task easier on those he left behind.*

*Due to the extraordinary generosity of Dr. Siobhan Ellison, who donated this great Champion to Old Friends in June, we were honored to have Precisionist in our care and humbled by the trust she put in us. We all wish he could have stayed a little longer. But in those brief four months, punctuated by frequent visits from his great jockey, Chris McCarron, Precisionist taught us a lot. Not just about how he liked his stall fluffed and where he liked his neck rubbed, but about dignity and, of course, class.*

*During several trips to Hagyard Medical for uncomfortable procedures with Drs. Aldinger, Hunt and Gomez and Mason, he never balked.*

*I didn't realize how great he was until he allowed me to be his friend for the last few months of his extraordinary life. He taught me a lot. And that's not easy, especially if you talk to my other teachers. He even told us when it was his time. We did our best to measure up to him, and we never quite*

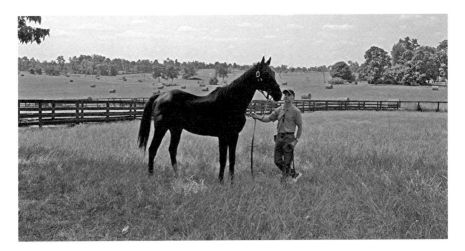

Jockey Chris McCarron visited Precisionist, one of his favorite horses, many times during the horse's retirement. *Courtesy of Old Friends.*

Award-winning author, Bill Mooney, left, stands with Michael Blowen in front of the Eclipse Award he donated to Old Friends. *Photo courtesy of author.*

*made it. But he didn't hold it against us. And there is nothing I can write that will convey the depth of my love for this spectacular creature.*

*The old guy put up with a lot as we tried to help him with a series of ailments that often afflict the elderly…both human and equine. Dr. Holly Aldinger and our farm manager worked diligently together to keep his quality of life at a level he so deserved.*

*When it was time, he made it easy. He looked at me with the same unmistakable stare he gave McCarron every time they entered the starting gate. He lifted his weary head and, for the first time, refused a carrot.*

*Both Precisionist and Taylor's Special* [who died on September 19, 2006] *have received some remarkable tributes over the past few difficult days. And while we all gave them a lot, they gave us so much more. Once again, thank you for allowing me to serve these great Champions.*[118]

One last, fitting tribute came to Precisionist a few months later. In the January 2007 edition of *Post Time USA*, Old Friends supporter, horse racing historian and author Bill Mooney had his article "Final Days for a Hall of Famer" published. It was about Precisionist's final day on the farm. His wonderfully written article went on to win the 2007 Media Eclipse Award for Writing in the News/Commentary category. Bill kindly donated the Eclipse Award statue to Old Friends, and it now sits on the mantle in Michael's home.

—⁂—

SARAVA WAS BORN in Kentucky on March 2, 1999, and was the son of Wild Again-Rhythm of Life, by Deputy Minister, a stallion that stood at Brookdale Farm in Versailles. Sarava started his racing career in England, where he raced three times but did not win. He returned to the United States in 2001 and raced fourteen more times between 2001 to 2004, winning three times and earning $772,620.

In his seventeen total races, two of his three wins came in stakes races. One was the Sir Barton Stakes at Pimlico, while the other, the most important one of all, was the 2002 Belmont Stakes, where he denied War Emblem the Triple Crown.

According to the Old Friends website, here is how Sarava's win in the Belmont Stakes unfolded:

*Belmont* [Stakes] *day, June 8, 2002. Kentucky Derby and Preakness winner War Emblem was bidding to become the first Triple Crown winner*

*since Affirmed in 1978, and during the parade to the post, all eyes were on the nearly black colt.*

*Parading to post position 12 was another nearly black colt, but few paid him much attention.* [His name was] *Sarava,* [and he] *had won the Sir Barton Stakes on the Preakness undercard and had run admirably since returning from the English turf as a 2-year-old.*

*Yet most regarded him as an afterthought entered by trainer Ken McPeek when favorite Harlan's Holiday lost the Derby and Preakness, and the Kentucky-bred son of Wild Again went off at odds of 70-1.*

*The field broke from the gate.* [Jockey Edgar] *Prado placed Sarava in the colt's favorite spot, stalking relaxed on the outside. War Emblem, who had stumbled at the start, gave way as, suddenly, star runner Medaglia d'Oro surged forward, and with him, splitting horses, the long shot Sarava.*

*It was Sarava who grabbed the lead. The two dueled fiercely and Sarava leapt ahead by half a length to the wire.*

[On] *that Belmont day, it was Sarava who went to the winner's circle to receive the accolades for a race beautifully run. He had spoiled a potential Triple Crown, but he was the longest shot ever to win the Belmont, and paid $142.50.*[119]

After the victory, one of his owners, Gary Drake, said in a BloodHorse. com article, "'I thought this horse had a great cruising speed in the mornings over this racetrack. [Jockey] Edgar [Prado] shook him up and put him in the race and settled him, and when he started picking them off on his own I thought he had every opportunity to win. When he turned for home and made the lead I looked at [trainer] Kenny [McPeek] because I wanted to make sure I was seeing what I thought I was seeing. I thought maybe I had the wrong horse. But Kenny said we were gonna win so I started cheering him down the lane."[120]

During his career, Sarava competed against Funny Cide, Evening Attire and Perfect Drift until 2005, when he began his stud career at a number of farms in Florida, finally ending up at the Appleton family's Bridlewood Farm near Ocala, Florida.

When the then 13-year-old Sarava was retired, his co-owners, Gary Drake and his wife, Kitty, of Louisville, as well as Paul and Susan Roy of Great Britain, decided to retire him to Old Friends.

Sarava arrived at Old Friends on September 29, 2012, from Bridlewood Farm, and he has lived in the front paddock behind the Old Friends office ever since. In that paddock, he is the first horse seen on every tour, and he

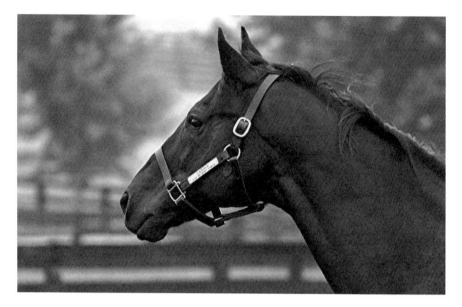

Sarava surveys his new paddock on the day he arrived at Old Friends in September 2012. *Courtesy of author.*

quickly learned that when he sees people coming, there's usually carrots to be handed out. He eagerly makes his way over to the fence to greet everyone.

Sarava's arrival was an important milestone for Old Friends, as the dark-brown stallion was the first Classic winner to be retired to the farm, all thanks to the Drakes, who are quite fond of their beloved stallion. From time to time, you will see them visiting Sarava at Old Friends, treating their retired champion to carrots and other treats.

## Chapter 10
# Other Old Friends Retirees, Past and Present

While any time at Old Friends is beautiful, there are two specific times of the day that are favorites of Michael Blowen: early morning and close to sunset. Mornings at Old Friends are very peaceful. It is the time of the day when the farm is starting to "wake up." The sun is rising over Summer Wind Farm across the street, and the shadows are beginning to stretch across each paddock.

The horses are anticipating breakfast, which Michael loads into a small vehicle that he will use to make his rounds. Meanwhile, the barn cats—BeBe, Button and Dina—are running around the barn waiting for Diane to feed them, as is Timmy, who waits back at the garage for his cat food, too.

Soon, with the cool morning breezes blowing and the sun coming over the horizon, Michael, sometimes accompanied by Diane, drives out of the barn and begins the rounds, stopping at each paddock, greeting each horse and giving him or her breakfast, topped with a few carrots. A new day has begun at Old Friends:

> *My favorite part of the whole aspect to Old Friends is to do the feeding in the morning. Some days, like in the winter, you don't want to get up and you don't want to do anything, but you always feel better once you've done it. Morning feeding gives you a chance to interact with every one of the horses and see their personality.*
>
> *I know when they're running up and jumping up and down and getting very excited, it's really not because of me—it's because of the feed. But to*

*see them exhibit all of their different personalities and watch them having a little fun, no matter how much the rest of the day may bring its daily irritations, it makes it worthwhile. It keeps reminding you of why you're doing it. So you don't get caught up in pettiness, and you don't get caught up with the humans all day long. You get caught up with the horses in the morning, and it just sets the day up. No matter what, it makes the day better.*

*One of the great things is that some mornings, when it's really cool, and they've had a really nice evening, and they're all feeling good, they'll gallop as you drive along their fence line bringing them their food. And so you'll see Affirmed Success and Futural and Mike the Spike, just running. There are no jockeys, no betting, no saddles or no trainers. You know, they're Thoroughbreds, and they're only bred for one reason, and that's to run. And to watch them run for the pure joy of it is a real honor and a real privilege to be able to observe that because they're phenomenal athletes.*[121]

Dream Chase Farm (where Michael feeds), the place tourists get to visit each day, now has anywhere from fifty-five to sixty-five horses on it at any given time. Along with all the horses that have been talked about so far, there are many other stallions, geldings and mares waiting to greet visitors each day.

Each Old Friends' tour guide takes visitors around the farm in different ways. Many begin by coming down the lane between the paddocks of Sarava and Gulch, who are located behind the visitor center, while other tour guides might take a different route and go up the main road to the barn. Either way, visitors get to see as many of the horses as time and their legs (it's a walking tour, after all) will allow.

—⁂—

Once you walk past Gulch and Sarava, one of the first horses you see near the barn is Afternoon Deelites, who was owned by singer-songwriter Burt Bacharach, whose former wife, Angie Dickinson, has visited the farm. A favorite of Old Friends' volunteer Alex LeBlanc, Afternoon Deelites was born in 1992 and was the son of 1978 Triple Crown winner Affirmed.

Afternoon Deelites, who is also the sire of another Old Friends retiree, Popcorn Deelites, was the winner of seventeen of his forty-two starts and $2,285,315 in earnings. Ridden by jockey Kent Desormeaux, he won six graded stakes races, including the two Grade 1s, the Hollywood Futurity and the Malibu Stakes. According to Kent, "Afternoon Deelites is still one of the fastest horses I've ever ridden!"[122]

After his racing career, Afternoon Deelites stood at Airdrie Stud in Midway, Kentucky, which is owned by longtime Old Friends supporter and former Kentucky governor Brereton Jones.[123]

Across from Afternoon Deelites is Mixed Pleasure, who is the son of Sucha Pleasure-Sea I'm Lucky, by Windy Sea. Mixed Pleasure raced as a 2- and 3-year-old, had five wins in his twenty-two starts and earned $140,175. He was then retired to stud, where he did not produce many winners.[124]

In 2012, Mixed Pleasure was donated to Old Friends, where he became a favorite of Old Friends volunteer John Bradley:

> *The first time I came to Old Friends as a visitor I came to see another of the many great residents that live here. However, when I met Mixed Pleasure, I was amazed by his sweet soul, gentle eyes and how he likes to greet visitors during tours. When I became a volunteer, I felt sad for him; over the course of time, his teeth have become worn, and he was unable to eat carrots. Many of our wonderful volunteers had tried different treats for him but were unsuccessful. I took him some shredded carrots, he loved them, and we have been great friends ever since.*
>
> *Words can't express what his friendship means to me, and every moment I'm with him is immeasurable. I can spend hours just watching him graze or giving him a well-deserved grooming, if he's in the mood. I love all the horses at the farm, but he has a special place in my heart…While conducting tours many visitors have told me I have a wonderful horse; my reply is, "He's not my horse; I'm his human."*[125]

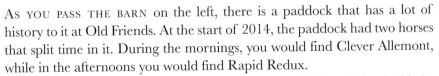

AS YOU PASS THE BARN on the left, there is a paddock that has a lot of history to it at Old Friends. At the start of 2014, the paddock had two horses that split time in it. During the mornings, you would find Clever Allemont, while in the afternoons you would find Rapid Redux.

Clever Allemont was born in 1982, the son of Clever Trick, and when he hit the racetrack, he became one of the early favorites for the 1985 Kentucky Derby after winning his first six races, including the Southwest Stakes and the Rebel Stakes at Oaklawn. Then a leg injury sidelined him, and his racing career was never the same. In total, he won eight times and earned $316,329 in forty-seven starts.

Clever then stood at a number of farms and quietly disappeared from the racing world until he was discovered twenty years later at a kill pen in

Kansas. Thanks to the efforts of a number of people, including the Fans of Barbaro and some people on an online horse racing forum run by Alex Brown, Clever was rescued and arrived at Old Friends in January 2009. He thrived there, and in 2014, he became the oldest horse on the farm at age 32.

Clever was a lot of fun to watch in his paddock. He was old, blind in one eye and almost totally deaf, but he never let it bother him, as he would prance oh-so-lightly on his feet, an equine dancer, as he trotted around his paddock, where he spent his mornings happily in retirement—a retirement he almost did not have a chance to enjoy.[126]

Sadly, Clever, who was one of the kindest, gentlest horses at Old Friends and a favorite of all the children who visited him, had to be euthanized due to colic on Memorial Day, May 26, 2014.

RAPID REDUX is the other horse that spends time in that same paddock, usually in the evenings. Rapid, a son of Pleasantly Perfect, was born in 2006. In his career, he won twenty-eight of forty-two lifetime starts and $361,609. However, what he is best known for are the two racing records he tied or set.

In 2011, Rapid tied Citation's record for nineteen wins in one year, and then, by the time he finished his career in 2012, he had won twenty-two consecutive races, another record, and retired with his streak intact.

Trained by David Wells, who worked very hard to get Rapid Redux sent to Old Friends in May 2012, Rapid was given a special 2011 Eclipse Award and was awarded the Vox Populi Award, which was established by Secretariat's owner, Penny Chennery, and voted on by racing fans.[127]

—m—

TWO OTHER HORSES that have called that paddock home are Wallenda and Flying Pidgeon.

Wallenda was born in 1990, and his sire, Gulch, also is retired at Old Friends. He was also another horse returned to the United States from Japan thanks to the efforts, and financial assistance, of Old Friends supporter Cot Campbell, owner of Dogwood Stable in Aiken, South Carolina, who owned him.

In his racing days, Wallenda, who was named after Karl Wallenda of the Flying Wallendas, won seven races and $1,025,929 in thirty-three career starts. Among his biggest wins were the Louisiana Super Derby (G1), the Pennsylvania Derby (G2), the Stuyvesant Handicap (G3) and the Suffolk Downs Breeders' Cup Handicap.

Flying Pidgeon takes a trot around his paddock on a quiet Sunday morning in 2008. *Courtesy of author.*

Wallenda arrived at Old Friends in April 2007. Shortly after, a party was held at the farm that was headlined by the Flying Wallendas, who came to meet their namesake.[128]

THE OTHER HORSE that lived in that paddock for a time was the magnificent Flying Pidgeon, who was owned by Jane White, the head of the Flying Pidgeon syndicate.

Born in 1985 as the son of Upper Case, Flying Pidgeon won twelve of his fifty-six starts and $1,154,337.[129]

"Flying Pidgeon was very famous for his flying finishes on the grass," recalled Jane White fondly. "I remember seeing a tape of the Arlington Million in which I never saw him at all because he was so far behind the pack and just a blur passing the finish line third. I don't think the announcers even saw or mentioned him!…His portrait hangs above me, and his name remains my e-mail address."[130]

Upon the completion of his stud duties, Jane and the syndicate chose to send him to Old Friends in October 2006.

"Michael and Old Friends are top drawer and do much to help us remember and pay tribute to the racing greats of the past which were lucky enough to live out their retirement there," said Jane. "Flying Pidgeon showed up at Michael's door in 2006 at the age of 25, toothless and thin. I was so grateful for the special carrot mash Michael made him to help nurse him back to better health. I knew that the stallion would receive the very best of care at Old Friends, but I was very impressed with the extra care they gave our guy."[131]

Sadly, in December 2008, Flying Pidgeon was euthanized due to the infirmities of old age, but he is still remembered fondly to this day.[132]

—m—

IF YOU CONTINUE along the lane past that last paddock, you will find Ogygian and Bull In The Heather on the left.

Ogygian is another Old Friends retiree that came home to the United States and Hurstland Farm from Japan, thanks to the efforts of Madeline Pickens, the wife of T. Boone Pickens. Madeline Pickens had kindly paid to have both Ogygian and Fraise returned to the United States and retired to Old Friends. Ogygian arrived at Old Friends on August 16, 2005.

From the start of his retirement, Ogygian has been under the watchful eye of one of his biggest admirers, Beth Tashery Shannon, a longtime volunteer at Old Friends. According to the Wikipedia entry about Ogygian, which was written by Beth, Ogygian was born on March 17, 1983, in Florida.

As Beth wrote:

> *The muscular bay Ogygian left his mark on 1980s racing as the "swift but star-crossed" fastest son of Damascus. His dam, Gonfalon (by Francis S.), from the Cequillo female line, is also second dam (maternal grandmother) to millionaire Honour and Glory. Named after Ogygian, the island of the nymph Calypso in Homer's Odyssey, Ogygian was raced as a homebred by Tartan Farms. His trainer was Jan Nerud, son of John Nerud, who had trained Damascus' fiercest rival, Dr. Fager. Remembered as "the nation's fastest 2-year-old of 1985," Ogygian won the 1985 Belmont Futurity Stakes (G1), but a shin injury prematurely ended his 2-year-old campaign. Back in training that December, he kicked the rail, receiving the injury that he was to battle through the rest of his race career. For the first time, bone chips were removed from his right hind ankle. Though the expected winter-book favorite for the 1986 Kentucky Derby, he did not heal in time to embark on the Triple Crown trail.[133]*

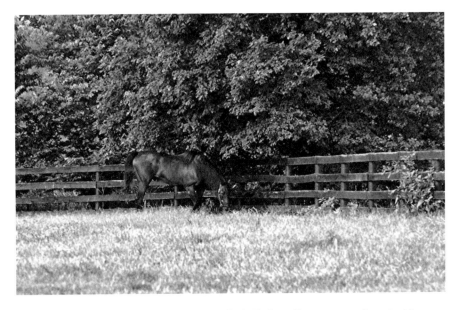

Ogygian, a favorite of Old Friends volunteer Beth Tashery Shannon, stands under his favorite tree in his paddock early one Saturday morning. *Courtesy of author.*

In his career, Ogygian won seven of his ten starts and $455,520. He retired to stand at stud in 1997 and stood at Claiborne Farm before being sent to finish his stud career in Japan in 1995.[134]

In 2005, Ogygian, who lost his left eye due to an injury, was retired from breeding and returned home to the United States, where he was retired to Old Friends, along with Fraise.[135] Even before Ogygian arrived at Old Friends, however, Beth was a fan of him, and soon after Old Friends moved to Georgetown, she became a volunteer at the farm, where she has spent countless hours with her favorite horse:

*Late August 2005 at Hurstland, I already had a share in him. In fact, I mailed in my check for the share before Ogygian returned to America. Having heard a rumor that Old Friends was returning "some O-horse" home from Japan and hoping it might be Ogygian, I phoned Michael, learned that it was and hurried to send that little bit that I hoped would help.*

*I wasn't fortunate enough to have ever seen Ogygian race, but I loved his sire, Damascus, and his best grandson, Johannesburg. I was only able to visit him a few times at Hurstland but became a volunteer when Old Friends and I both moved to Georgetown in the summer of 2006.*

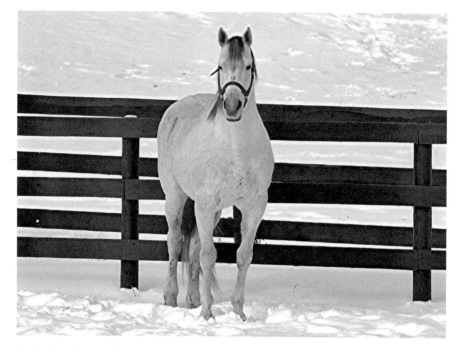

Bull InThe Heather blends in with the snow surrounding his paddock on a winter day. *Courtesy of author.*

Bull InThe Heather and Michael Blown show off Bull's Breyer horse model. *Courtesy of author.*

A look across the farm at some of the paddocks at Old Friends. *Courtesy of author.*

A view of the front of the farm up the hill to the main barn. *Courtesy of author.*

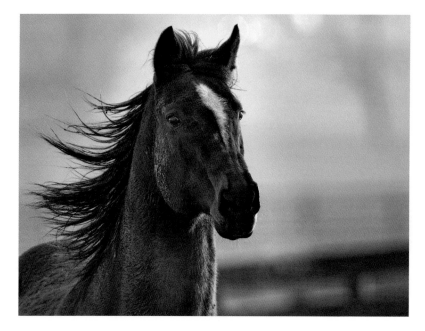

A portrait of Sunshine Forever. *Courtesy of Matt Wooley/EquiSport Photos.*

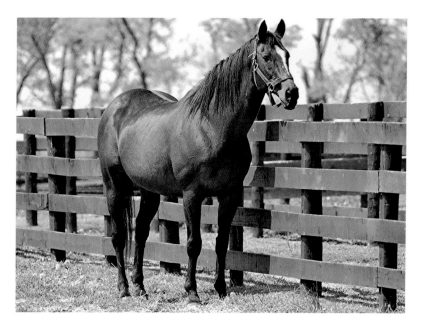

Sunshine Forever stood proud at Old Friends for ten years. He passed away on January 4, 2014, at age 29. *Courtesy of author.*

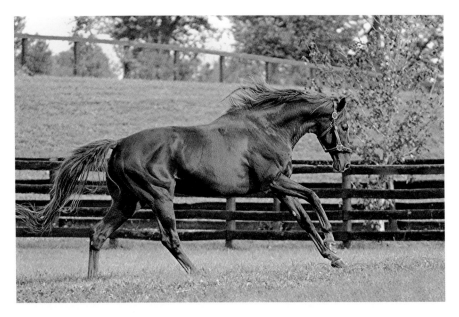

Creator charges across his paddock. *Courtesy of author.*

Afternoon Deelites runs toward the fence hoping for a treat. *Courtesy of author.*

Narrow Escape, a mare, was the first official retiree acquired by Old Friends. *Courtesy of author.*

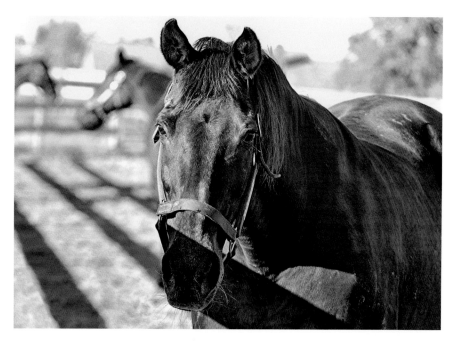

Bonnie's Poker, the dam of 1977 Triple Crown winner Seattle Slew, spent many years as a retiree at Old Friends. *Courtesy of author.*

Ruhlmann was the first horse donated to Old Friends by Jerry and Ann Moss. *Courtesy of Kate Dunn.*

Ogygian performs one of his favorite tricks with Michael Blowen. *Courtesy of Stan Grossfeld*/Boston Globe.

Fraise stands with Alfred Nuckols, owner of Hurstland Farm, on the day he arrived in August 2005. *Courtesy of Hurstland Farm.*

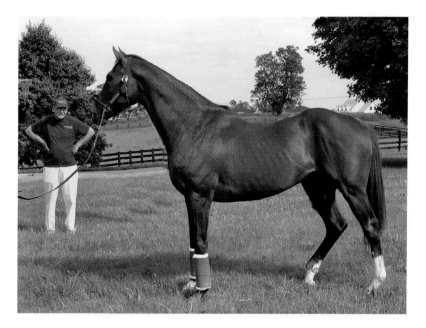

Precisionist and Michael Blowen look at each other on the day the 2003 Hall of Famer arrived at Old Friends. *Courtesy of John McDaniel.*

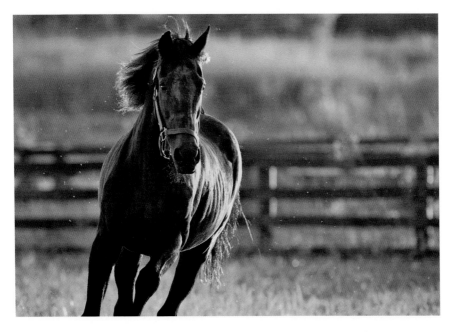

Fortunate Prospect—or "Grandpa," as he was called—was still running around his paddock well into his 30th year. *Courtesy of Matt Wooley/EquiSport Photos.*

At 32 in 2014, Clever Allemont still enjoyed running around his paddock like a youngster. Sadly, he passed away on Memorial Day, May 26. *Courtesy of author.*

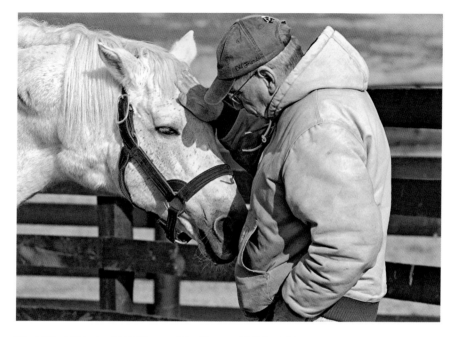

Black Tie Affair, the 1991 Horse of the Year, and Michael Blowen share a quiet moment together. *Courtesy of author.*

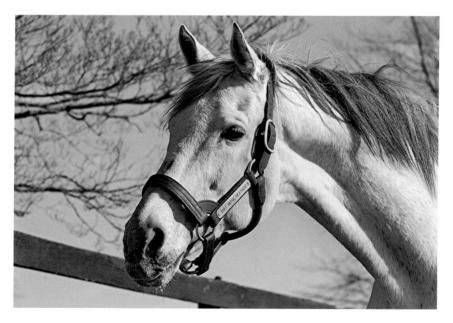

Bull In The Heather enjoys a beautiful Kentucky morning just a few days before he died in April 2014. *Courtesy of author.*

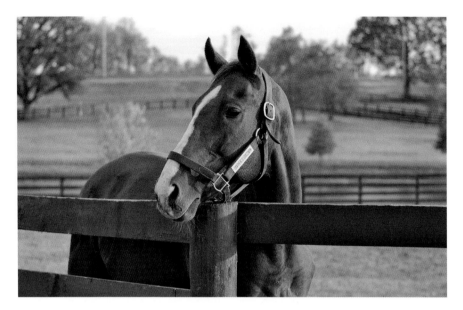

Danthebluegrassman is one of the most photogenic Thoroughbred retirees at Old Friends. *Courtesy of author.*

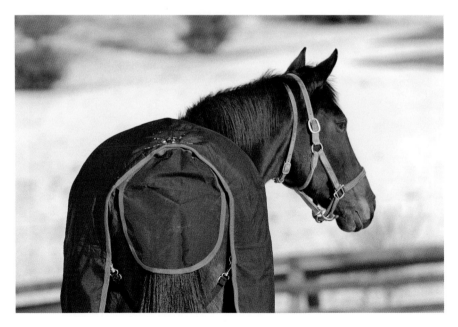

Hidden Lake looks around her paddock on the day she arrived in January 2009. *Courtesy of author.*

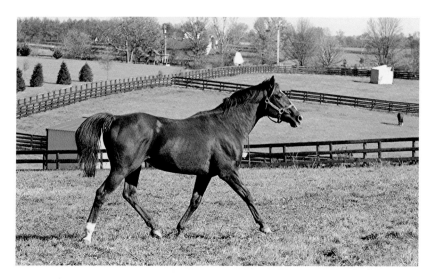

Tinners Way, one of the last great sons of 1973 Triple Crown winner Secretariat, trots around his paddock. *Courtesy of author.*

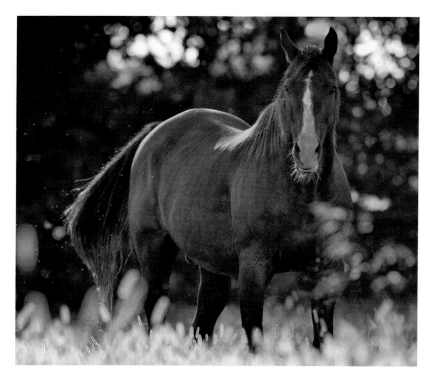

Williamstown, a son of 1977 Triple Crown winner Seattle Slew, likes to hide under the trees in his paddock. *Courtesy of Matt Wooley/EquiSport Photos.*

"Who loves ya, Pops?" That's what Special Ring (right) seems to be saying to Popcorn Deelites as he gives his buddy a kiss on the cheek. *Courtesy of author.*

Michael Blowen races Marquetry in his paddock. *Courtesy of Anne Eberhardt/* BloodHorse *magazine.*

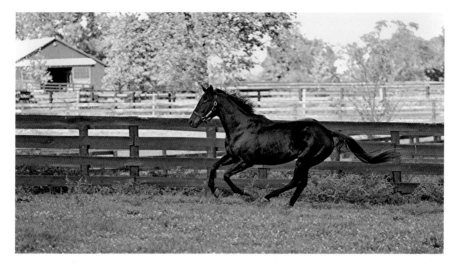

Sarava, the upset winner of the 2002 Belmont Stakes, enjoys a run in his paddock. *Courtesy of author.*

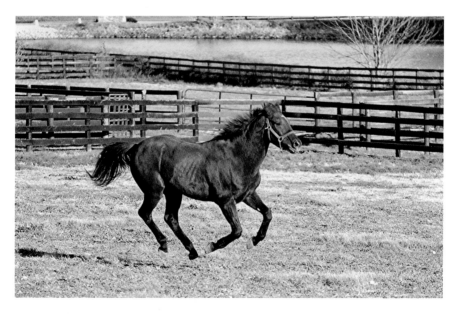

On a sunny autumn afternoon, Gulch gallops around his paddock. *Courtesy of author.*

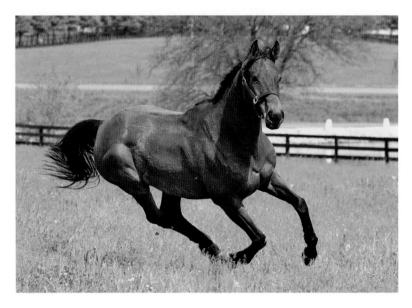

Appygolucky, with his trademark red halter, romps around his paddock on the day he arrived. *Courtesy of Candice Chavez.*

Michael Blowen and his buddy Little Silver Charm can often be found walking or running around the farm together. *Courtesy of author.*

Old Friends at Cabin Creek: The Bobby Frankel Division has become a great success since its opening in July 2010. *Courtesy of Connie Bush.*

Travers Stakes winners Thunder Rumble and Will's Way can sometimes be found racing along their fence lines at Cabin Creek. *Courtesy of Connie Bush.*

*Above*: On a beautiful autumn afternoon in 2014, some Old Friends horses enjoy grazing next to a pond at Nuckols Farm. *Courtesy of author.*

*Left*: Some Old Friends horses lined up in almost perfect symmetry on the side of a hill at Nuckols Farm. *Courtesy of author.*

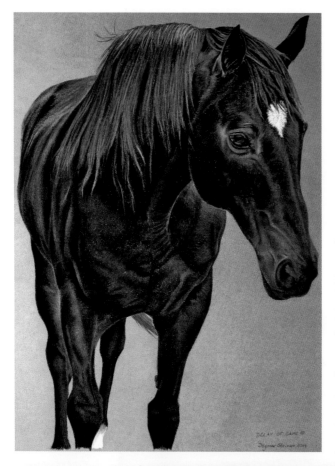

*Left*: Dagmar Galleithner Steiner, a very talented artist, painted this image of her favorite Old Friends retiree, Delay of Game. *Painting courtesy of Dagmar Galleithner Steiner.*

*Below*: Rapid Redux, the horse, and Princess, the cat, take a stroll along the fence line together one evening at Old Friends. *Courtesy of author.*

*Our friendship began the first day I volunteered. At the end of the day, I leaned on his fence just to watch him graze. I'd heard he was aloof and didn't expect anything else, but he came right over and began making friends. He's smart (an understatement!) and seems to know who loves him. Of course, the more I got to know him, the more I loved him, not for Damascus or Johannesburg but just for himself.*

*What makes Ogygian special? What a question. How do you ever sum up what's special about the spirit, the wisdom and the thousand beautiful and loving ways of someone you love?...He is the most wonderful horse in the whole world.*[136]

Bull InThe Heather had been living across from Ogygian but passed away in April 2014 at age 24 as this book was being written. "He was the toughest horse we ever had there and probably Ferdinand's greatest son," said Michael. "It's tough to lose him. It's tough to lose that legacy."[137]

A living reminder of his sire, 1986 Kentucky Derby winner Ferdinand, Bull InThe Heather was bred at Claiborne Farms. A second-place finisher in the 1993 Fountain of Youth Stakes, he became the long-shot winner of the Florida Derby (G2), the biggest win of his career, that same year.

He was the second favorite in the 1994 Kentucky Derby but finished eleventh to Sea Hero. He also raced in the Belmont Stakes and finished poorly to Colonial Affair, who was ridden by Julie Krone, the first female winner of one of the Triple Crown races. In his career, Bull won three times and $508,338 in thirty-three starts. Upon completion of his stud career, he was retired to Old Friends in 1997.[138]

Bull also was known to have very bad feet. In fact, special shoes had to be made for his front feet, which cost upward of $500 each. But those shoes, created by Dr. Brian Fraley, kept Bull happy and healthy during his retirement at the farm.

One of Bull's biggest claims to fame while at Old Friends was when Breyer, the model horse company, made a model of the beautiful great gray stallion. In fact, he is the first Old Friends horse to have a Breyer model made in his likeness.

—◆—

Near Bull's and Ogygian's paddocks are the homes of two pairs of gelded paddock pals: Danthebluegrassman and Flick and I'm Charismatic and Arson Squad.

Danthebluegrassman was born in 1999, a son of Pioneering. He was named after Dan Chandler, the son of Governor, Senator and baseball commissioner A.B. "Happy" Chandler and the uncle of U.S. Representative Ben Chandler; Danthebluegrassman was trained by Bob Baffert.

In 2002, he was scheduled to run in the Kentucky Derby but was scratched just prior to the race. However, later that year, he won the Northern Dancer Stakes at Churchill Downs. In his 7-year racing career, he won eight times and collected $423,794 in earnings in forty-seven starts. Upon his retirement, he came to Old Friends in February 2008.[139]

Dan is proof that horses do not just have intelligence—they can think. In his time at Old Friends, Dan has proven that he is very smart and knows exactly what he is doing. For example, Dan had been at Old Friends for a while and was enjoying his retirement. He spent his days grazing in his paddock and taking naps in the sun. One day, jockey Chris McCaron called and asked Michael if he had any young horses he could use at his North American Riding Academy for jockeys to learn on. Michael said there were a couple, and Dan was one of them.

Well, Chris picked up the horses Michael had mentioned, including Dan, and took them to his school to see if they would work out. A few days later, Chris called Michael and told him to come and pick Dan up because he was limping and must have hurt his leg.

Michael went over to the school, and sure enough, Dan, who had always been very healthy, was limping. So, they loaded Dan onto the trailer and brought him back to Old Friends. They took him off the trailer, looked him over and then tried to decide whether to put him in a stall or back in his paddock to see what would happen.

The decision was made to put him back into his paddock. So, they walked him over to his paddock, and as they were walking, they noticed that Dan's limp was "subsiding." Then, when they put him in his paddock, off he went at a trot; miraculously, he had absolutely no appearance of a limp anymore. He just went into the paddock, trotted away, started grazing and was back into his "retirement" mode.

Could a horse actually fake an injury to get what he wants? Dan sure proved that it was possible.

FLICK WAS BORN in 1992 in England and was a son of Kris (GB)-Thakhayr (Ire), by Saddler's Wells.

He began his racing career in England, but as a 2-year-old, he was purchased by Judy Carmel, who later brought him to the United States to race and where he had more success. All told, he had eight wins in fifty-one starts and earned $515,738.

Paddock pals Danthebluegrassman (right) and Flick ham it up for the camera. *Courtesy of author.*

However, late in Flick's his career, he suffered a torn suspensory ligament, usually a career-ending injury. However, "Judy allowed him to receive what was then a revolutionary new treatment. Bone marrow cells were injected at the tear, and his own body rebuilt its tissue. As Flick healed, he made it clear he wanted to race. His late-maturing pedigree had a chance to develop."[140]

Flick went on to win a few more races before being permanently retired. He arrived at Old Friends in January 2009, where he joined Danthebluegrassman. The two became good pals.[141]

ACROSS FROM THEM are the two other gelding pals, I'm Charismatic and Arson Squad, both of whom recovered from leg injuries to enjoy life at Old Friends.

Arson Squad was born in 2003, the son of Brahms-Majestic Fire, by Green Dancer. In his racing career, he had nine wins in twenty-five career starts and made $1,190,181. Among his biggest wins were the Swaps Breeders' Cup Stakes (G2), the Strub Stakes (G2), the Meadowland Cup (G2), the Skip Away Stakes (G3) and the Alysheba Stakes (G2).

His career came to an end in 2011 when he suffered a debilitating injury in a training accident at Gulfstream Park. After surgery, which was performed

by Dr. Larry Bramladge in Florida, he recuperated at Lexington's Rood and Riddle Equine Hospital, where he earned a reputation as a good patient.

He recovered, and in February 2012, Arson Squad arrived at Old Friends for his retirement, thanks to his owner, Samantha Siegel, who continues to support him.[142] In talking about Arson's Squads life with her, Samantha said:

> *I purchased Arson Squad as a yearling from the Fasig Tipton July sale in Kentucky. We ran him in California* [with Bruce Headley] *until they switched to synthetic tracks. He wasn't successful on those, so we sent him to our New York–based trainer* [Rick Dutrow], *where he returned to winning while running on dirt.*
>
> *While he was at Gulfstream during the winter, he had a breakdown while training. I sent him to Dr. Bramladge at Rood and Riddle to put him back together.*
>
> *When I called the hospital for an update, I was told that Michael Blowen from Old Friends was asking about him. I had met Michael at the yearling sales, so I called him, and he told me the local fire department was willing to sponsor our horse. I was delighted to know that after he recovered from surgery he had a great home to go to.*
>
> *Michael found a great paddock mate for him* [in I'm Charismatic], *and the two are best buddies. I could never have dreamed of such a great solution. I visit him a few times a year when I come to Lexington.*[143]

His paddock mate, I'm Charismatic, who also had a hard racing life, was saved through the efforts of Mary Adkins-Matthews and her husband, Jason.

Born in 2001, I'm Charismatic is the son of the 1999 Kentucky Derby and Preakness winner Charismatic, who was injured in the Belmont and failed to win the Triple Crown. He now stands at stud in Japan. I'm Charismatic was a hardworking racehorse and raced well through age 7. He was then sent to Beulah Park in Ohio, where he won one more time as an 8-year-old in a $2,500 claiming race.

Fortunately, his courage had won the admiration Mary and Jason Matthews, who purchased him in February 2010 from Gary Egloff, his last racing owner. I'm Charismatic raced a total of ninety-two times, with ten wins, fifteen places and seventeen shows, for a total of $201,298.[144]

Mary, a big fan of his sire, Charismatic, one day noticed I'm Charismatic and said to husband Jason, "Look at this, there is a horse named I'm Charismatic running at Beulah Park in two days. It doesn't look like he has

I'm Charismatic (left) and Arson Squad became buddies the moment they were paired together in a paddock. *Courtesy of author.*

been running very well."[145] On that fateful day, she decided that she was going to buy I'm Charismatic.

"First of all, Jason asked if I was crazy," said Mary. "We didn't own land to put a horse on, and we had no idea how to care for a horse. Secondly, at that point, yes, I was crazy."[146] So, she began searching for a place where she could put I'm Charismatic before she even purchased him.

"When I called Michael, he explained that he had a long waiting list. I said, 'Okay, but I am still going to get this horse.' I think to this day Michael knew I wasn't kidding and agreed—as long as we got him to Old Friends, he had a home. Michael did this not as a favor to us, but rather as a favor to I'm Charismatic."[147]

After a number of phone calls and talks with I'm Charismatic's trainer, Robert Roe, and owner, Gary Egloff, the deal was done. Then, Old Friends volunteer Tim Ford made the arrangements to transport I'm Charismatic to Old Friends.

"On February 22, 2010, we drove to Beulah Park to deliver the check and pick up I'm Charismatic," said Mary. "The weather wasn't the greatest, but we made it to Old Friends in Georgetown and were there to watch I'm Charismatic take his first steps to retirement and the end to his prior life of being told what to do."[148]

Today, after a lengthy recovery from a leg injury, I'm Charismatic shares a paddock with Arson Squad, who also recovered from his own leg injury. Together they run and play to their hearts' content.

"I'm Charismatic is happy now to share his life and friendship with Arson Squad," said Mary. "With what both of these horses had to endure to make it to this point, [it] is a testament to Michael Blowen and all the staff and volunteers at Old Friends. I'm Charismatic will now spend many blissful years romping in his paddock, getting treats from visitors and just being thankful he can just be a horse."[149]

—⁂—

IF YOU CONTINUE around the front of the farm, you'll come across the two loving showoffs of Old Friends, Popcorn Deelites and Special Ring.

Popcorn Deelites was born in 1998, the son of Old Friends retiree Afternoon Deelites. However, his biggest claim to fame was that he was one of the horses that portrayed Seabiscuit in the Oscar-nominated film starring Tobey Maguire and Jeff Bridges in 2003. Pops is the horse you see in the gate sequences before the horses race.

In fact, in a bit of humor on the Old Friends website, it says that Popcorn's biggest win was "[a]s Seabiscuit in the match race against War Admiral, of course!"[150] In real life, "Pops," as he is affectionately called on the farm, did have a five-race win streak at Turf Paradise from January to April 2004. But that would be his best moments on the track. All told, in his racing career Pops ran in low-level claiming races and allowance races and had eleven wins in fifty-eight starts, earning $56,880.

Pops arrived at Old Friends in March 2005, thanks to the efforts of Old Friends volunteer Cindy Grisolia and Michael Blowen, and he was paired with Fraise. However, upon Fraise's death, he was then paired with Special Ring, and the two have been inseparable ever since. In fact, if you take one out of the paddock for any reason, you have to take the other, or he will go crazy until he is back with his buddy.

SPECIAL RING WAS A SON of Nuryev and was born in 1997. He had a much better racing career than his buddy Pops. He began racing in France, where he won the Prix Saint Patrick and the Prix Altipan. However, it was when he came to the United States that he really hit his stride, so to speak, and by the time his career was over, he had ten wins and $915,279 in earnings in twenty-nine career starts.[151]

On a tour, it is fun to watch Pops and Special Ring interact, as they can be two of the biggest clowns on the farm. During summer, you can always find them playing keep away with each other's fly masks, and during

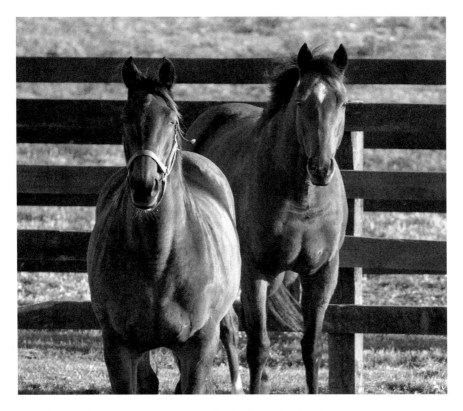

Longtime paddock pals Popcorn Deelites (in front) and Special Ring have become inseparable since being paired together. *Courtesy of author.*

feeding, it's always funny to watch Pops sneak in and take a bite out of Ring's bucket before Ring, the paddock leader, gets there and chases him away. Then, Pops, seemingly with a smile, goes on to his own bucket to enjoy his own feed.

Ring also does one of the funniest tricks on the farm. Upon request (you have to know how to ask), he'll tilt his head up, lift his upper lip and show you his racing tattoo. He then gets a few extra carrots.

What makes the trick even funnier is that when Pops sees his pal getting the extra carrots, he tries so hard to curl his upper lip up and show you his tattoo, too. But he has never been able to do it…yet. (For the record, he does get extra carrots for his effort.)

—m—

DOWN NEAR THE FRONT of the farm resides Kiri's Clown, who was born in 1989, the son of 1975 Kentucky Derby winner Foolish Pleasure-Kiri (GB), by Kris (GB).

In his racing career, Kiri loved the turf, won sixteen times and earned $1,005,469 in sixty-two starts. One of his biggest wins came in the 1995 Sword Dancer Invitational Handicap (G1) at Saratoga, where he dueled former Old Friends retiree Awad to the wire, won the 1-1/2-half-mile race and set a track record with a time of 2:25.45.[152]

Kiri's Clown was retired to Old Friends by his owner Mary Sullivan, who also donated a lot of money to the farm. She visits Kiri a few times every year.

Kiri's Clown had many races against his fierce competitor, Awad, and upon their retirement to Old Friends—Kiri in August 2006 and Awad in September 2006—they were placed in adjacent paddocks, where you could sometimes see the two racing each other along their fence line, maybe recalling their former exploits together.

Sadly, Awad, who was by Caveat-Dancer's Candy, by Noble Dancer, and won fourteen times in seventy starts, including the 1995 Arlington Million (G1), as well as earned $3,270,131, passed away in July 2011.[153]

For a while after his death, you could sometimes see Kiri standing in the corner of his paddock, looking over his fence for his old friend. Today, Kiri lives in another paddock closer to the front of the farm, where he spends time mostly by himself, but he still happily greets visitors when they stop by on tours.

—⁓⁓—

ANOTHER HORSE that used to live in a nearby paddock but has moved around a lot on the farm is Swan's Way. "Swannie," as he is called on the farm, was born in the Virgin Islands, which is not really known for its Thoroughbred racing, in 1989 by Smile-Bright Swan, by Quack.

The Old Friends website calls Swannie one of the farm's most deserving retirees. "The hardest of hard knockers, he managed eight wins in eighty-one lifetime starts, but had sixteen places and fifteen shows and earnings of $64,715. Swannie's last race, at age 15, came on August 11, 2004."[154]

Swannie is a handsome bay and a favorite of longtime Old Friends volunteer Tom Beatty, who speaks warmly of his favorite:

> By the great champion sprinter Smile, Swan's Way is not the best known of Smile's offspring. That honor probably goes to I'll Get Along, the stakes-winning dam of Smarty Jones, the Eclipse-winning 3-year-old colt who thrilled race fans in 2004 as he missed the Triple Crown by less than a length.

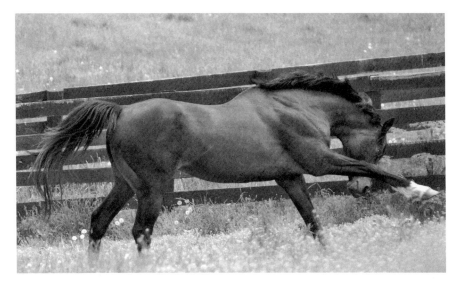

Swan's Way enjoys a run around his paddock one sunny day. *Courtesy of Laura Battles.*

*No, Swannie is far less important in racing annals, but if they bestowed an Eclipse Award for heart and determination, Swannie would win it outright...*

*Swannie's racing career ended on August 4, 2004, at age 15 when he was eased shortly after starting a six-furlong claimer at Suffolk Downs where he had launched his racing career in 1992. Time had finally taken its toll on this old blue-collar survivor.*

*Swannie arrived at Old Friends in 2005 and was one of just fifteen horses that moved to Dream Chase Farm in 2006 when we moved our operation from Hurstland Farm in Midway. Later that year, he developed ulcers in his eyes and was confined to the barn during the days so we could treat his condition; he got his exercise at night, when the sunlight wouldn't hurt his vision.*

*Over the years, Swannie has entertained our visitors with his good looks and pleasant personality. He loves his carrots and mints, and the fact that he's a pauper among other millionaire stallions doesn't bother him a bit. He wouldn't want it any other way.*[155]

ONE OF THE FIRST PADDOCKS that Swannie lived in at Old Friends was near the front of Michael's house. It was also home at one time to Marquetry, one of the most beautiful retirees on the farm.

Born in 1987, Marquetry was by Conquistador Cielo-Regent's Walk (CAN), by Vice Regent (CAN). In his career, he won ten of thirty-six career starts and retired with earnings of $2,857,886. He was a Grade 1 winner on both dirt and turf, registering victories in the 1991 Hollywood Gold Cup Handicap (G1), the 1992 Eddie Read Handicap (G1) and the 1993 Meadowlands Cup Handicap (G1).[156]

Marquetry truly seemed to enjoy his time at Old Friends and understood what "retirement" was all about. He'd happily greet guests at his fence, and he would race around his paddock whenever Michael challenged him to a footrace.

Sadly, due to a stall accident on February 1, 2013, Marquetry had to be euthanized. In a tribute on the Old Friends website, Michael talked fondly of the beautiful chestnut Thoroughbred:

> *We lost Marquetry this morning. He was humanely euthanized after injuring himself in a freakish stall accident. We await the results of the necropsy. But that is not, of course, what really matters. Selfishly, I can say that I lost one of my best friends, as did anyone who ever had the good fortune to lay eyes on one of the most magnificent Thoroughbreds who ever lived.*
>
> *I like, to one degree or another, all of our retirees. But I only truly love a few, and Marquetry is at the top of the list. I apologize, in advance, for this sort of self-indulgence, but Marquetry was a very, very special friend.*
>
> *…But Marquetry was, as we all are, mortal. But for many years he had me fooled. We have, and will, retire many great horses. But none will ever take his place. I can promise you that.* [157]

THOSE ARE JUST A FEW of the horses on the front of the farm. As you head up the hill toward the back of the farm, there are many more horses. One of the first paddocks is where Commentator currently lives.

Commentator, a son of Distorted Humor, was bred in New York in 2001 and was raced by Old Friends supporters Tracy and Carol Farmer. In his career, he won fourteen races and $2,029,845 in twenty-four career starts. Among his biggest achievements were his two wins in the Whitney Stakes at Saratoga in 2005 and 2008.

In that first Whitney win, he battled "it out with Horse of the Year, Saint Liam, in one of the most memorable finishes of the year," according to the Old Friends website.[158]

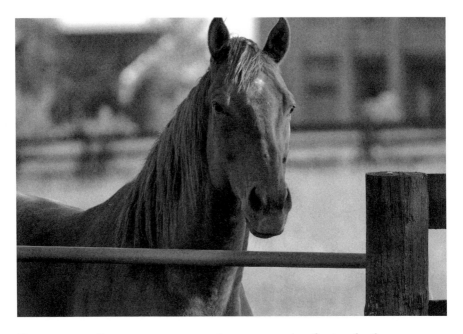

Commentator strikes a sweet pose on a cool summer morning. *Courtesy of author.*

At 8 years old, after finishing third in the 2009 Whitney Stakes, he was retired. His retirement, in September 2009, was honored at Saratoga with the first running of the Commentator Stakes. He galloped onto the track to lead the post parade and then received a peppermint key to the city of Saratoga Springs.[159]

"Having been around a great athlete like that is really something," said owner Tracy Farmer. "He gave it his all every time. He deserves a good rest and a good life."[160]

Prior to Commentator residing in that paddock, two other loveable horses called it home: Wallace Station, who was a youngster at the time and has since moved on but will one day return to Old Friends, and Appygolucky.

Appygolucky was brought to Old Friends by longtime volunteers Vivian Morrison and her friend Bea Snyder, who together call themselves Team Ivytree. Appygolucky was born in 1997, the son of Fair American-Apalachee Wind, by Apalachee. In his career, the hardworking horse won 24 times and earned $127,799 in 107 career starts. To this day, he still holds the track record at Beulah Park for the mile.[161]

Sadly, "Appy," as he was called, who always wore his trademark red halter, passed away in 2009, but he is remembered fondly by Viv:

*I was standing by the rail watching the post parade of a race when a scrappy little bay gelding wearing a red halter trotted onto the track. I remember the marks on his forelegs and later learned they were scars from pin-firing. He wore the number six. I liked him immediately. He ran third.*

*After the race, I noticed that he immediately headed for the winners circle. It took all of his jockey's strength to steer him away. He was determined. I knew then he was something—he had ego to spare and the heart of a champion. No one could tell him otherwise. Over there, that's where winners go! I found out later, he was the hardest of knockers—over one hundred starts, a track record and six figures the hard way. He was a champion.*

*He knew his job. He was a racehorse. He was also 10 years old with an outsized knee. I knew his heart would outrun his legs if I didn't somehow step in. Bea came out to Beulah with me and saw him heading to the winner's circle after he'd won the next time. She agreed we had to try to help retire him.*

*After following his career, Appy then disappeared for several months. By then, Bea and I had started supporting the work of Old Friends. I reached out to friends of friends, who remembered him but had no idea where he was. After frustration and worry, I received a friend request from Laura Rackar, who at the time handled the trainer listings as a volunteer for Canter Ohio. Just after accepting her request, I sent her an e-mail asking for her help in finding Appy.*

*To my relief and surprise, she replied almost immediately. She had been in Charlie Lawson's barn just that week and knew Appy! He had been on lay-up at a farm and had just returned. At 12, he was back in training. Laura and I agreed the clock was ticking, so I waited while she put out the word. I went to Michael [Blowen] and put the past performance sheet on the table. He saw the 107 starts and wrapped his fist on the table. 107 starts, that's a hard knocker…*

*Laura had been working with Appy's groom, Sherry, who thought the world of him. She agreed to approach Charlie Lawson about retiring Appy. The end of the Beulah meet was on Derby Day. My father and I went to the backstretch that day to meet Charlie and plead our case. As I walked the shed row, Sherry introduced me to each horse. The big gray with one eye, the lanky chestnut who was morning line favorite, the feed lot rescue nursed back to health and on the right, a small dark bay with alert eyes and a coat*

Appygolucky (right) and his paddock pal Wallace Station peacefully grazed together. *Courtesy of author.*

*covered with patches of new hair growth after a bout with rain rot. On his head he wore the same old red halter. I stepped to him and said, "Appy, I've watched you run. You don't know me yet, but I'm your friend and I'm taking you home. I promise I will not leave you. You're going home."*

*About that time, an elderly man stepped out of a red pickup truck. Sherry introduced us. "This is the lady who wants to retire Appy to that real nice, big farm in Kentucky." I produced another Old Friends brochure. He looked at it and then sealed Appy's fate with four words: "Well, that'll be okay."*

*Appy went to River Downs with the rest of the Lawson string that week. From there, he hitched a free ride on a Sallee horse transport to Dream Chase Farm. I had kept my promise.*

*When he arrived at Old Friends, it was such immense relief. And tears of gratitude to Michael and all those who made it possible. It never seemed quite real, on the other hand, and sadly, I later understood why. His stay with us was meant to be a short one.*[162]

According to Viv, Appy earned the title "Claiming King of Beulah Park" from Michael. Appy set the record for a mile of 1:35.47 at Beulah

Park on January 17, 2003. With the closing of Beulah Park in 2014, the "scrappy little bay gelding wearing his trademark red halter" now holds that record forever.[163]

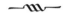

As you continue up the hill, there are two final paddocks before you reach the Back 40, and they contain two of the horses that have the biggest name pedigrees on the farm: Williamstown, the son of 1997 Triple Crown winner Seattle Slew, and Tinners Way, the son of 1973 Triple Crown winner Secretariat.

Williamstown, or "Big Willy," as he is called, was born in 1990 and was the son of Seattle Slew-Winter Sparkle, by Northjet (Ire). In his racing career, he ran twenty-four times, won five times and earned $361,276. His biggest wins were the 1993 Withers Stakes, the 1992 Thistledown Stakes and the 1992 Prevue Stakes. One of his biggest claims to fame came in the 1993 Withers at Belmont Park, where he set a track record of 1:32.79 while carrying 124 pounds—13 more than the previous record holder, Conquistador Cielo. Williamstown's record stood for ten years until it was broken by Najran in the Westchester Handicap on May 7, 2003, with a time of 1:32.24.[164]

Williamstown came to Old Friends in 1997 thanks to a call by "Lisa Penkal from Frank Aubrey Insurance in Lexington. It seemed her company had just paid off a fertility claim on a black stallion at the University of Minnesota, and they were going to euthanize him on Friday, the day after Thanksgiving. Not because he was ill or hurting, but because he was no longer useful to the program. So she was calling to ask Michael if he would possibly take him in."[165]

Shortly after, Michael was able to make the arrangements, and Williamstown came to Old Friends to enjoy his retirement.

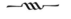

Across from "Big Willy" is Tinners Way, who was born in 1990 and was the final foal of the great Secretariat. In his racing career, Tinners Way earned $1,849,452, with seven wins in twenty-seven career starts.

As a 3-year-old, he raced, and won, in Europe. Then, as a 4-year-old, he returned to the United States and was trained by Bobby Frankel. At ages 4 and 5, he won the Grade 1 Pacific Classics at Del Mar racetrack in two consecutive years. Following his racing and stud career, he was donated to Old Friends in September 2010 thanks to Phil Leckinger.[166]

AFTER THOSE TWO HORSES, you crest the top of the hill and reach the gate to Old Friends' Back 40. Once there, you are transported into a different world. It is so quiet and peaceful back there. You can no longer hear the traffic on the highway in front of the farm, and unless a tractor or other vehicle comes up the hill to feed the horses, all you hear are the sounds of nature—the horses, cows on the farm next door, the birds and the wind blowing. It is absolutely amazingly serene.

In the Back 40, there are some twenty to thirty geldings and mares at any given time. A few of the geldings in the first paddock on the right past the gate are Kudos, Cherono and Bonapaw. Kudos and Cherono both came to Old Friends thanks to their owners, longtime Old Friends supporters Jerry and Ann Moss.

Kudos was born in 1997, the son of Kris S.-Souq, by Damascus. During his career, he had much success on both the grass and dirt. In all, he won seven races in twenty-four starts and collected $1,238,935. His biggest wins came in the 2001 Jim Murray Handicap, the 2002 Oaklawn Stakes (G1) and Marino Handicap and the 2003 California Stakes (G2).[167]

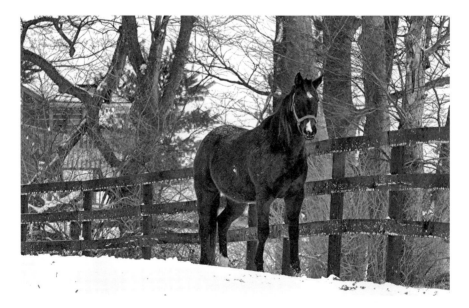

Kudos always seems to enjoy a snowy day. *Courtesy of author.*

Cherono was born in 2002, the son of Grand Slam-Smooth and Classy, by Old Friends retiree Ogygian. His racing career was cut short due to an injury, but he did race three times and earn $4,040. The Mosses took care of him until he was once again healthy and then sent him to Old Friends in December 2010 to enjoy his retirement.[168]

Bonapaw was sired by Sabona-Pawlova, by Nijinsky, and was born in 1996. In his racing career, he took his owners, twins Dennis and James Richards of New Orleans, on an amazing ride.

Purchased for $6,500 at the Keeneland yearling sale, Bonapaw ended his career with eighteen wins in forty-eight starts and earned $1,118,752. His three biggest wins came in the 2002 Vosburgh (G1), the 2002 Hashin Handicap (G3) and the 2001 Count Fleet Sprint (G3).

The purchase of Bonapaw by James and Richard Dennis is an interesting story according to the NTRA website. "Big Jim literally backed into the purchase [of Bonapaw]," said Dennis Jr. "He was looking at another horse at the sale, and Bonapaw bumped into him from behind. When he turned around, he liked the look in Bonapaw's eye and decided on the spot to buy him instead."[169]

After the purchase, the fun began. "The Twins never had anything before but claimers and low-level allowance horses," said Dennis Jr. "They never even had a horse run in a stakes race before [Bonapaw]. They had never left the Louisiana circuit and didn't even know how to travel with a horse. They were just two guys selling tires and having fun. It's been a remarkable ride to finally have a horse like this. Bonapaw took them to New York, to run at Churchill Downs on Derby Day, all the way to Dubai and everywhere in between."[170]

The two brothers ensured that Bonapaw, who had treated them so well with his racing success, would have a safe and happy retirement when they sent him to Old Friends in March 2009.[171]

In the paddock next to those geldings is another paddock full of geldings that includes Futural and Affirmed Success, two longtime buddies.

Longtime paddock buddies Affirmed Success (left) and Futural graze side by side on a cool morning. *Courtesy of author.*

At one time, the two could always be found together. Today, they each hang out with other horses in their paddock. However, if one of them is not feeling well, they will band together once again, with the healthy horse protecting the injured one and keeping the other geldings from bothering him. It is very sweet to see.

Affirmed Success was born in 1994 and sired by 1978 Triple Crown winner Affirmed. In his racing days, he won seventeen times in forty-two starts and earned $2,285,315. Among other races, his biggest wins came in New York in the 1998 Vosburgh (G1) and the Forego Handicap (G2) and in 1999 in the Cigar Mile (G1).

Upon his retirement, he was placed at the Kentucky Horse Park in Lexington before joining Old Friends in October 2007.[172]

Futural was born in 1996, the son of Future Storm. In is racing career, Futural scored twelve wins in seventy career starts and earned $816,107. Two of his biggest wins were the 2001 San Bernadino Handicap (G2) and the Mervyn Leroy Handicap (G2). Futural also finished first in the 2001 Hollywood Gold Cup, with jockey Chris McCarron riding. However, he was disqualified and put back to third, an incident that still makes Chris's blood boil to this day.

Upon his retirement, he was sent to Old Friends in December 2006. A year later, he would be paired with Affirmed Success, and the two would become longtime paddock pals.[173]

ACROSS FROM THAT PADDOCK lives Sea Native. Born in 1999 the son of Line in the Sand-Miss Big Pie, by Big Bluffer, Sea Native raced twenty-three times, won twice and earned $64,760.[174]

Sea Native's owner, Angela Black, who calls him "Rhett," purchased the beautiful chestnut and enjoyed years of riding him. Eventually, his feet caused more and more discomfort, so she began to look into finding him a place to retire.

She heard about Old Friends from a fellow horsewoman, and so she wrote Michael Blowen a long, "beautiful" letter, as Michael says, about her horse. The letter totally touched his heart, and he agreed to bring Sea Native to Old Friends.

"Once we arrived and he settled in, I could tell everything was going to be fine," said Angela. "He was paddock mates with Tour of the Cat, who had also raced at Calder. They hit it off right away, which took me by surprise, as Rhett had always been a bit of a loner in the pasture. It made me wonder

Sea Native, or "Rhett," as he is called by his owner, Angela Black, runs around his paddock. *Courtesy of author.*

if perhaps they remembered each other from back in the day, maybe shared the same shed row, and were happy to be reunited.

She continued, "My first visit back to see him was about one month later. It was like one of those movie scenes. I went to the gate and called for him; his head popped up from that Kentucky grass he was enjoying, and we both ran to each other!…I like to visit at as often as I can, at least once or twice a year, and he always seems as happy to see me as I am him. I know he's happy at Old Friends, and that makes me happy. I've also made some good friends myself along the way."[175]

Today, Sea Native lives in a paddock with Judge's Case, with whom he had bonded, and together they enjoy their retirements.

Before Sea Native moved into that paddock, it was the home of Delay of Game. A son of 1990 Preakness winner Summer Squall, Delay was born in 1993. During his career, he had sixteen wins in forty-eight starts and earned $809,023. His biggest wins came in 1997 in the Stuyvesant Handicap (G3), as well as consecutive wins in 2001 and 2002 in the Tampa Bay Breeders' Cup Stakes.[176]

When his racing career ended, he was retired to Old Friends and arrived in December 2010. In his time at Old Friends, Delay has become a favorite of Dagmar Galleithner Steiner, a German-born artist who is currently working on a book of paintings of the horses of Old Friends. She currently lives in California with her husband, jockey Joe Steiner.

"I felt an immediate connection with DOG the day Viv [Morrison], Bea Snyder and I visited him there in his back paddock," said Dagmar. "I didn't want to leave. And, of course, the fact that his name is DOG in short, I take as a sign—dog lover that I am."[177]

Those are just some of the horses that call the main Old Friends farm home these days. There are also other horses living on annex farms around the area.

In Midway, about fifteen minutes away from Old Friends, there are another twenty-three to twenty-five horses being boarded at Nuckols Farm. Among those horses, you will find Riva Way, who along with Cappucino Bay and Bingo had lived at Dr. Byars's farm for many years together and were a happy little band.

Riva Way is a fan favorite, as he has two of the great Meadow Stables horses in his pedigree: 1973 Triple Crown winner Secretariat and 1972 Kentucky Derby and Preakness winner Riva Ridge.

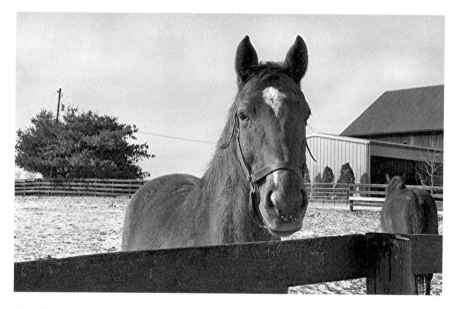

Riva Way comes to the fence for a visit on a snowy afternoon. *Courtesy of author.*

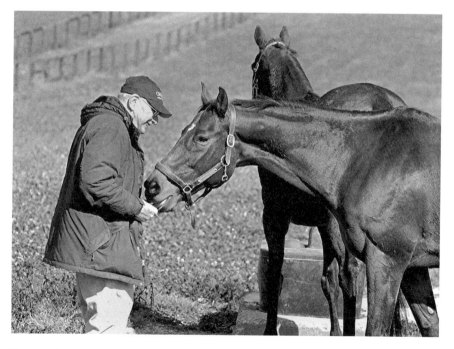

Summer Attraction gets a carrot from Michael Blowen on the day the two friends were reunited. *Courtesy of author.*

Born in 1998, he didn't receive the "great" racing genes of his two more famous ancestors, but he always did try hard to live up to their achievements. During his career, Riva won eleven times in fifty-six starts and earned $109,915.[178]

ONE FINAL HORSE to mention currently boarding at Nuckols Farm is Summer Attraction.

Summer Attraction was a horse that Michael had purchased, lost and then reclaimed during his time as a trainer. Summer, who was born in May 1995 the son of Dominated-Summer Pasture, by Rajab, was a personal favorite of Michael's.

In his career, Summer ran in claiming races mostly, as well as a few allowance races. All told, he won four times and earned $28,214 in thirty-four career starts.[179] Upon his retirement from racing, Michael sent Summer to a farm in Massachusetts, where he had a second career as a lesson horse. Over time, Michael lost track of Summer, and when he tried to locate the farm, he couldn't find it or Summer anywhere.

With the passage of time, he just figured that Summer had died and moved on with things at Old Friends. Then, in the summer of 2011, out of the blue, the woman who had owned the farm called Michael, told him that it was time to retire Summer and asked if he would like to have him back. Without hesitation, Michael said, "Yes, absolutely." The woman then added one caveat: Summer had a good buddy named Dusty Fields. She'd send Summer if he would accept his buddy, Dusty, as well.

Michael wholeheartedly agreed, and on October 29, 2011, a horse van pulled up to one of the Old Friends' annex farms, and Summer Attraction and Michael were reunited after being separated for almost ten years.

Summer and Dusty were placed in a paddock, where they ran around together for almost thirty minutes checking out their new home. When they finally settled down, they approached Michael, who fed them carrots and petted both of them, though he did give Summer a little extra attention. Then, in a rare show of emotion, a choked up Michael said to Diane, who was there to watch the reunion, "He's home. Can you believe it? He's finally home."

THERE ARE MANY, many other horses that now live at Old Friends, too many to mention here—my apologies if your favorite was not mentioned. But please know that each and every one of them has his or her own heart-warming story, which you can learn about when you come out and visit sometime.

## Chapter 11
# Old Friends at Cabin Creek

### The Bobby Frankel Division

With Old Friends firmly established at Dream Chase Farm in Georgetown, Kentucky, Michael began looking at possibly opening up a satellite Old Friends farm in New York. Interestingly, New York was the original place that Michael had wanted to open Old Friends, but things just didn't work out at the time.

"When I first started the idea for Old Friends, I was sitting on the porch of the Washington Inn in Saratoga Springs," said Michael. "Now, I originally envisioned Old Friends being in Saratoga because I thought there's a lot of people there. However, there wasn't the correct property, there wasn't anything—nothing clicked. So, then we started looking in Kentucky, and that's when we decided that Old Friends would be here. But I always had in the back of my mind that I wanted to do something in New York. But I could never find the right people."[180]

Then, as had always seemed to happen for Michael and Old Friends, fate stepped in once again. "I got an e-mail from JoAnn Pepper," said Michael. "She said, 'We have a little farm in Greenfield Center. My husband, Mark, and I, we really like the idea of Old Friends. I worked for Nick Zito,' and so on."

"I'm thinking, this could be really interesting," said Michael. "So, we exchanged a few more e-mails, and then a few months later, I went up to see her and Mark and see the farm, and I thought it was not quite big enough, it was not perfect, but JoAnn was so enthusiastic, and she so understood the idea, and she so loved the horses, I knew that we had to make this match work. And it worked."[181]

Indeed it did, and in November 2009, Old Friends opened its first satellite farm for retired Thoroughbreds at JoAnn and Mark Pepper's Cabin Creek Farm in Greenfield Center in New York. Cabin Creek is a forty-acre farm located outside Saratoga Springs, in New York, and once it was open, it began to receive horses almost immediately. In addition, a plan for a grand opening in July 2010 began to take shape.

Soon after Old Friends at Cabin Creek opened, Hall of Fame trainer Bobby Frankel, a supporter of Old Friends who was a New York native and raced his horses a lot in New York, died on November 16 from leukemia. In honor of Bobby, the farm changed its name to Old Friends at Cabin Creek: The Bobby Frankel Division. The new name was received very well by everyone.

According to an article on BloodHorse.com in November 2009, "Cabin Creek features 12 stalls, two round pens, five finished paddocks, and has raw space available for development and growth. The first resident, Moonshadow Gold, a 10-year-old New York–bred gelding acquired through the efforts of several equine-welfare advocates, will arrive later this week…The property will be leased by Old Friends (Michael Blowen, president), a non-profit organization, which will continue to control all acquisitions and financials… The Peppers, who built Cabin Creek from scratch 15 years ago, will handle day-to-day operations."

"When we built the farm, my goal was to do Thoroughbred retirement," said JoAnn Pepper, who began her life with horses as a groom for Nick Zito. "Initially we did boarding and foaling as a way to establish ourselves, but I always came back to the idea of retirement. I had read about Old Friends, and this summer an article in *The Saratogian* prompted me to call Michael. I explained that my farm was empty, and I wanted to emulate what he was doing. It just clicked that we would do it together."[182]

In the same article, Michael said of the new farm, "This was just an amazing opportunity. I have always felt there was a need for Old Friends all over the country."[183]

On naming the farm after Bobby Frankel, he added, "While I was on my way back from Saratoga, I heard about Bobby's passing, and I immediately thought that a place in New York that was home to both top champions and bottom claimers would be a perfect memorial to his career. Any horse trained by Frankel will be given priority at Old Friends at Cabin Creek."[184]

A short while after Bobby Frankel's death, Michael got a call from his friend Dottie Ingordo-Sherriffs, who is the wife of trainer John Sherriffs, who trained Zenyatta for Jerry and Ann Moss. Dottie was the business

manager for both Jerry Moss and Bobby Frankel, as well as executor of Frankel's will.

The reason she called was to tell Michael that, in his will, Bobby Frankel had left Michael and Old Friends his entire Thoroughbred horse racing trophy collection, as well as a sizeable donation. Today, the trophies are at Old Friends in Kentucky, and plans are being made to put them in a moving exhibition, which includes the Thoroughbred Racing Hall of Fame in Saratoga.

Over the next few months, the New York farm received a number of new horses, and then, on July 23, 2010, Old Friends Cabin Creek: The Bobby Frankel Division held its grand opening celebration.

According to an article about the opening in *The Saratogian*, "Old Friends founder and president Michael Blowen spent several minutes sharing memories of Hall of Fame trainer Bobby Frankel, for whom the farm was named. Frankel, who died in November 2009 following a long illness, stipulated in his will that his trophies be donated to Old Friends and also left money to the organization…'This will be his living legacy,' Blowen said of Cabin Creek."[185]

Today, Old Friends at Cabin Creek, now five years old and under the care of JoAnn and Mark and a number of dedicated volunteers, is home to fifteen Thoroughbreds.

SADLY, THREE OF THE RETIREES—New Export, whose nickname was Rio; Key Contender; and Crusader Sword—have passed away, Rio on July 27, 2010; Key Contender on June 29, 2012; and Crusader Sword, the oldest retiree at Cabin Creek, on May 9, 2014, as this book was being written.

The two "biggest" stallions at Old Friends at Cabin Creek are Thunder Rumble and Will's Way. Thunder Rumble, born in New York on March 31, 1989, the son of Thunder Puddles, out of the Lyphard mare, Lyphette (Fr), won eight times in nineteen starts and earned $1,047,552 in his career.

Thunder is best known as the first New York–bred Thoroughbred to win the Grade 1 Travers Stakes at Saratoga.

Will's Way, who is by 1989 Belmont Stakes winner Easy Goer, out of the Tentam mare, Willamae (Can), won six times in thirteen career starts and earned $954,400. He is best known for wins in the 1996 Travers Stakes (G1) and the 1997 Whitney Handicap (G1) at Saratoga.[186]

Will's Way was moved from Old Friends in Kentucky to the New York farm when it opened so that he would be closer to his New York fan base.

*Left*: Thunder Rumble shows why he is the king of Old Friends at Cabin Creek: The Bobby Frankel Division. *Courtesy of Connie Bush.*

*Below*: Will's Way, who now calls Old Friends in New York home, enjoyed a run in his paddock when he was still in Kentucky. *Courtesy of author.*

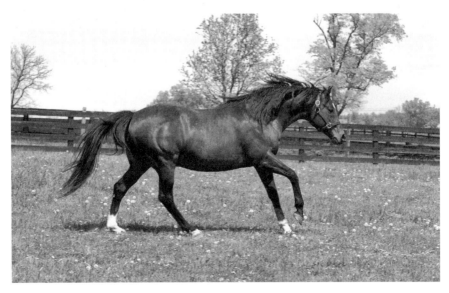

THREE OTHER THOROUGHBRED fan favorites at Old Friends at Cabin Creek are Moonshadow Gold, Red Down South and Zippy Chippy.

Moonshadow Gold was born on February 14, 1999, the son of Golden Gear-Wacky Miss, by Miswaki. He raced for nine years, won sixteen times in eighty-nine starts and earned $338,777.[187] "Moonie," as he is called, was the first Thoroughbred to be retired to the farm, arriving in November 2009 when the farm first opened.

Red Down South was born in the Empire State on April 4, 2000, the son of Dixie Brass-Redeye Rain, by Instrument Landing. He raced thirty-two times, won two races and earned $116,650.[188] His best stakes finish came in 2005, when he finished third in the Cormorant Stakes at Aqueduct.

His paddock mate is fan favorite Zippy Chippy, the losingest horse in Thoroughbred racing history, as he finished his career with a record of 0-100. Zippy Chippy was owned and trained by Felix Monserrate, who acquired Zippy in 1995 in a trade for a 1988 Ford truck.[189]

Zippy Chippy (left) enjoys spending time with his buddy Red Down South at Old Friends at Cabin Creek. *Courtesy of Connie Bush.*

The closest Zippy ever came to a win was in a race late in his career, when he finished second. When the winning horse was going to be disqualified, Felix pleaded with race officials not to do that. If Zippy was going to win after all those years, Felix wanted it to be a win "on the track." In the end, the finish order was kept intact, Zippy was second and his losing streak continued—into legend.

Zippy Chippy, who is by Compliance-Listen Lady, by Buckfinder, was born in New York on April 20, 1991. He raced one hundred times and never won, but he did finish second eight times and third twelve times and earned $30,834.[190]

From the day they were put in the same paddock, Zippy and Red have been inseparable. Then, in the summer of 2013, the two Old Friends farms decided to make a swap for a few months; they sent Commentator to New York so his fans could see him and brought Zippy down to Kentucky so his Kentucky fans could meet him. Making the trip with Zippy was Red, as no one had the heart to separate the two, even for a little while.

# Chapter 12
## People and Events at Old Friends

There is no question that the retired Thoroughbreds are the main attraction and the reason for Old Friends' existence; however, the army of volunteers and the handful of full-time workers that take care of the horses and keep things running are the lifeblood of the farm. Without them, Old Friends would not be able to function.

Aside from Michael Blowen, the owner and founder of Old Friends, and his wife, Diane White, the longest-tenured employee of Old Friends and the person who keeps things in order and running is Office Manager Sylvia Stiller. Without Sylvia keeping the daily activities on the farm running smoothly and organizing the volunteers, tours, events, fundraisers and, well, pretty much everything, chaos would reign at Old Friends.

Sylvia began working with Old Friends when it started at Hurstland Farm. In fact, Sylvia actually worked for Alfred Nuckols at Hurstland and just began helping out Michael and Old Friends. "When I was hired at Hurstland, they shared me," said Sylvia. "I came on board in April of 2005. I don't think I had a title or anything. I just took care of the office stuff for both."[191]

Then, when Michael purchased Dream Chase Farm and was set to move the farm, Sylvia made the decision to make the move as well, and Michael was very happy to have her. "Sylvia was my secretary at Hurstland at the time, and she was doing some stuff for Michael," said Alfred. "So, when he got Dream Chase, she said, 'You know, I really enjoy it. Would it be okay…?' I said, 'You know, Sylvia, no problem. I know you love this. And right now, I

really don't need a full-time person any more. So that would be great. If you want to go with Michael, I certainly give you my blessing.' And, Sylvia has done so much [for Old Friends]…I mean, she pulls everything else (other than the horses) together."[192]

For Sylvia, her decision was just a matter of getting to do something just for the horses. "I worked on several horse farms [in the offices] before I became involved with Old Friends," she said. "I was delighted to be able to do something to specifically help the horses. To me, it is not just an industry."[193]

ANOTHER KEY PERSON in the history of Old Friends is equine veterinarian Dr. Doug Byars, who is considered by many to be one of the top equine diagnosticians in the world, if not the top one; he was head of the internal medicine unit at Hagyard-Davidson-McGee (HDM) veterinary firm in Lexington before retiring and starting his own equine consulting business.

When Old Friends started, Michael did not have a specific equine veterinarian whom he could call in case of an emergency. Instead, he worked with Hagyard:

> We had a great relationship with Hagyard at the time. A great relationship, which we still have with them today. They've been great to us. They sent us all these fabulous new interns, etc. But the problem was, they were young, and we needed somebody for these old horses that could make quick decisions. For example, we had a horse who was in trouble like Taylor's Special. We needed somebody that could make decisions and knew what they were looking at. Knew immediately whether this horse could be taken care of and, with the proper medical attention, could be all right. Or if the horse needed to be euthanized. We didn't want to wait because the horse was in distress. So Doug seemed to be the perfect one for that.[194]

Of course, Dr. Byars might never have been the one Michael would have considered asking if not for a fortuitous set of circumstances that set things in motion. "One day at the [Dream Chase] farm, Sylvia called me on the phone, and she says, 'Dr. Byars was just here. He left us $1,000 donation.'"[195]

Added Dr. Byars, "I met Michael briefly at another farm and got familiar with Old Friends through that introduction," he said. "I decided to make a donation based on my professional responsibility to the horses."[196]

Of course, Michael was very grateful for the donation. But the timing of the donation was fortuitous, as he was trying to find an experienced equine vet to help take care of the horses. So, when Sylvia called to let him know

about Dr. Byars's visit and donation, Michael thought to himself, "Whoa. That's great." The story of how he finally got Dr. Byars to be Old Friends equine vet is another interesting tale according to Michael:

*Now, I'm thinking to myself, I've got to thank him. I've always wanted to talk to Dr. Byars because his reputation preceded him. I mean, he was always considered to be the greatest diagnostic vet in Kentucky, in Thoroughbred horse racing, maybe in Thoroughbred horse racing in the world. The best diagnostic vet ever. So, I'm thinking, "Oh boy, this is something."*

*Later that afternoon, I call him up and thank him for the donation, and he said, "That's all right."*

*I said, "I don't want to impose on you…," although that wasn't true, I really did want to impose on him. I said, "If I brought a six-pack over, do you have time to talk to me sometime? I'll bring the beer and we can chat."*

*He said, "Okay, you can come over this afternoon at 4:30."*

*So, that afternoon, I went over to his office, and we sat around for two and a half hours and talked about a number of things, including Old Friends and retiring Thoroughbred stallions over the six-pack. Emboldened by the three beers I had, and sensing that he really did like this idea [of retiring Thoroughbred stallions], I got up my courage, and I said to him, "Dr. Byars, if I promise not to call you at two o'clock in the morning, would you be our vet?"*

*Well, he leaned back in his chair, and I'll never forget the look he had on his face—a very serious look. He looked like all the judges in the* Perry Mason *TV show. He said, "Well, I can only do it under one condition."*

*I said, "Okay, what's that?"*

*He replied, "That you will call me at two o'clock in the morning." And that's when it started.*[197]

Ever since then, until just recently in 2012, when he had to deal with some personal health problems, Dr. Byars has been the go-to vet at Old Friends. Over the years, he has worked with all of the great stallions on the farm and also had to make the tough calls on Precisionist and Black Tie Affair when it was their time.

"I was on my way back from Saratoga when he called me about Black Tie Affair," said Michael. "He said that Black Tie had taken a turn for the worst and that he couldn't wait for me to get back. That is what I liked about Doug. He'll do what's best for the horse, and if doesn't fit your schedule, too bad. He's always been that way…And, he's smart about it.

I mean, I don't know what it would be like. It would be like having Ted Williams as your batting instructor, or Johnny Unitas or Tom Brady as your quarterback coach. Whatever it is, that's the level that we're talking about because Doug's amazing."[198]

Added Dr. Byars, "I like and respect all horses, generally. Michael has respected my decisions to do right by the horse…I never had a problem in euthanizing a horse in need so long as it was dignified and humane."[199]

Michael has a number of great stories about Dr. Byars over the years. One of his favorites is when Dr. Byars tried to teach him how to use a stethoscope on a horse. The idea is one that Dr. Byars has always fostered, which is to teach people on the farms how to take a horse's vital signs while a vet is on the way to the farm. In that way, when the vet arrives, they can tell them, which could save time in helping with a diagnosis.

"I followed up on both Michael and Old Friends as something I would want to stay involved with," Dr. Byars said. "And I taught Michael and some staff how to do a physical exam on the horses, left them stethoscopes and provided for evaluations on incoming horses."[200]

Still, nothing could have prepared Michael for the lesson he would eventually learn when taking his "test" on what he had learned from Dr. Byars:

> *When we were at Hurstland Farm, I was a real, real novice with horses. I don't know a lot now, but I knew even less then. I would panic over the littlest thing. A horse would get a little cut or something, and I'd go, "Oh, should I call the vet?" And Alfred [Nuckols] would look at me like I was from outer space. And for good reason. He was an experienced horseman. He knew the difference between something that was not dangerous and not lethal and not terrible and something that was serious. You only called the vet when it was serious.*
>
> *When I first started, I wasn't that good at that. So, Doug decides he's going to teach me stuff, and one day, he gives me the stethoscope and teaches me how to use it. How to read the horse's gums and to make sure the gums are okay. That way, when we did have a problem with a horse, I can give him some information instead of just blabbing it and worrying.*
>
> *In times, he's given me all this information—how to take a temperature, how to get the heart rate and all that stuff—so I can give it to him when he called instead of going crazy. After about six months, he decides he's going to give me a test. I said, "Okay. Give me fifteen minutes and go pick out the horse."*
>
> *He said, "No, no. We can't do that. You know all these horses. I want to get a horse that doesn't know you."*

Michael Blowen honored his friend Dr. Doug Byars, Old Friends' longtime equine veterinarian, by naming the main road on the farm after him. *Courtesy of author.*

*I said, "All right, fine."*

*Fifteen minutes later, I get all my stuff together that I need, and we get into his SUV and off we go. We drive down this back road and that back road and another back road, and we finally come to this barn. Here's two horses in the barn—there's a chestnut and kind of little bay horse. It didn't look like much.*

*And Dr. Byars said, "All right, go get that horse* [the small bay one]. *That's the one we're going to do. Here's a shank."*

*So, I reach out, put the shank on him and I look down at his name plate, and it says "Storm Cat."*[201]

It turned out that the farm Dr. Byars had taken Michael to was Overbook Farm, and the stallion Michael was going to "get his test" with was the great sire, Storm Cat. Michael's first thought as he led Storm Cat out of his stall was, "Oh my God, I'm going to get a test on Storm Cat." Michael said that he told Dr. Byars that he was so nervous he was hearing his own heart rate. But in the end, Michael did okay and passed his test.

Dr. Byars has been a familiar face at Old Friends and has done so much to help keep the horses happy and healthy. Over the years, he and Michael

have formed a wonderful friendship as well. In a ceremony during an event at Old Friends in 2012 honoring the staff of the *Thoroughbred Times*, Michael announced that the road leading up the hill to the main barn would be renamed Byars Way to honor his friend Dr. Byars for all he has done for Old Friends.

While it was a short ceremony, it was also an emotional one, as Dr. Byars was making his first appearance at Old Friends since his health issues had started, and he truly seemed to appreciate the honor.

ONE OF THE NEWEST supporters of Old Friends is jockey Rosie Napravnik. Since she began officially riding in 2005, Anna "Rosie" Napravnik has become not just one of the all-time best female jockeys in history but one of the top jockeys in Thoroughbred racing.

With more than 1,600 victories to date in her career, she has won riding titles in Delaware and Maryland, and most recently, in 2014, she wrapped up her fourth consecutive riding title at Fair Grounds in New Orleans. In addition, she is the only female jockey to ride in all three Triple Crown races and has accomplished some firsts in those as well.

In 2013, she guided Mylute to a fifth-place finish in the Kentucky Derby, the best finish by a female jockey in that Classic. In addition, she rode Mylute to a third-place finish in the 2013 Preakness as well, which was the best finish by a female jockey in that race.

Two of Rosie's biggest career wins came in the Kentucky Oaks. In 2012, she became the first female jockey to win the Oaks. She did it aboard Believe You Can, which is owned by longtime Old Friends supporter Governor Brereton Jones. Then, in 2014, she won the Oaks again, this time aboard Untapable. In another milestone, Rosie won the 2012 Breeders' Cup Juvenile (G1) on Shanghai Bobby.

Still, while she has accomplished all of those "firsts" for a female jockey, she'd rather just be considered one of the jockeys, something she has worked very hard at to gain the respect of the other jockeys, trainers and owners.

A hard worker, with steely determination and multiple injuries over the years to prove it, Rosie is, without question, one of the best jockeys in the business. She also happens to be friends with Lorita Lindemann, the person who "rescued" Little Silver Charm many years ago. And it was Lorita who first told Rosie about Michael and what he was doing at Old Friends, which led to her involvement with the retirement farm and being named to Old Friends' board of directors.

Jockey Rosie Napravnik, who has become a strong supporter of Old Friends, stands with her new buddy, Little Silver Charm. *Courtesy of Sylvia Stiller.*

*My trainer up at Suffolk Downs, Lorita Lindemann, who is like my daughter and who has always been interested in what happens to these horses after their racing careers are over, was friends with Rosie. And I was always a fan of Rosie's, and I liked Rosie when she was at Maryland and some other places. She always rode her horses out, and because she was a female. Also, this was before she got noticed, and now all her horses are overplayed instead of underplayed.*

*Lorita gave me Rosie's number, and she gave Rosie our number. We started talking about Old Friends, and she loved it. She loved the idea of it. She came to see the horses. We had a couple horses she road, including Salzburg, who's no longer at Old Friends, and Ready's Rocket. She got very enthusiastic about it, and I was thrilled because I knew that it would be really good to have her as an ambassador for Old Friends. And she's a natural ambassador.*

*And she's been fabulous. She talks about Old Friends. She gets the other jockeys involved. When she was in the Breeders' Cup, she had all the other jockeys sign her saddle. Every Breeders' Cup jockey signed it, and we got to auction it off.*[202]

On her very first visit to Old Friends, she brought along one of her dogs, Leo, and while Michael took Rosie on a tour of the farm in a golf cart, Leo followed them all the way around the farm and seemed to have a blast, as did Rosie. She even became one of the many admirers of Little Silver Charm.

"Rosie loved Little Silver Charm. She really liked him," said Michael. "But she was very aware and knew the records of a lot of the horses we had here that she didn't even ride. I'm hoping when she ever settles down, and is not riding all the time, I hope she retires early and retires to Old Friends and she can come work for us. That would be fabulous."[203]

Soon after her visit, Michael asked Rosie to join the board of directors, which Rosie agreed to do. In addition, Rosie modeled a series of hats created by Sally Faith Steinmann of Maggie Mae Designs®, who creates them each year as a fundraiser for Old Friends.

Photos were taken by Matt and Wendy Wooley of EquiSport Photos to help promote the hats, which were auctioned off, and a series of behind-the-scenes videos was created by the Wooleys that became very popular on the Internet.

"I am a big fan of Old Friends," said Rosie. "Especially since I've gotten the opportunity to ride some top horses, and I always keep in mind that they may be winning a Breeders' Cup race this year, but next year they may need

a place to reside in retirement for life…And they live long! They will only continue to be Champions if we continue to honor them."[204]

OLD FRIENDS HOLDS A NUMBER of events each year to help raise funds for the horses and the farm, with the biggest event each year being Homecoming, which occurs on the Sunday following the Kentucky Derby. At the events, there's food, drinks and music; appearances by jockeys and trainers; and then an auction of horse memorabilia, donated to the farm by many people.

One of the newer annual events, which is entering its fifth year, is Ferdinand's Ball, which is held in Louisville each year on the eve of the Kentucky Derby. According to the event's website, Ferdinand's Ball was created to help give Thoroughbreds a dignified and humane retirement following their racing careers:

> *Ferdinand's Ball was founded in 2009 by sisters Kim Boyle and Aimee Boyle Wulfeck and has quickly become on of the premier events of Derby weekend, bringing the focus back to the athletes that make horse racing possible.*
>
> *Ferdinand's Ball was named in honoree of 1986 Kentucky Derby winner Ferdinand, a horse who made millions for his owners. Once his racing and stud careers stopped producing money, this champion was sold into slaughter.*
>
> *Every year, thousands of these majestic athletes are faced with the same horrific fate once their careers have ended.*
>
> *Ferdinand's Ball was created in order to raise funds to combat this problem and awareness to prevent it. Partnering with Old Friends Equine Retirement Facility has created the opportunity to reach these goals. Allowing Thoroughbreds the humane and dignified retirement they deserve.*[205]

Along with all the fundraisers, there is also one serious event that takes place each year on Memorial Day. That is the day when Old Friends holds a memorial service for all the Old Friends horses that have passed away each year.

Special moments at the service include a eulogy presented by Eclipse Award–winning writer Bill Mooney; the playing of one last "Call to the Post" by longtime, and recently retired, Keeneland bugler Buckee Sallee; and a final toast to the horses with Woodford Reserve bourbon, which the distillery provides each year.

## Chapter 13

# Old Friends Comes Full Circle and Looks to the Future

*August 24, 2013*

It was almost ten years ago that Sunshine Forever and Creator arrived at an airport in New York, and with their arrival, things began to move forward at high speed with the growth of Old Friends.

Now, on this beautiful August summer day—Travers Stakes Day at Saratoga—Michael Blowen and Nicholas Newman, a volunteer at Old Friends, were standing at another airport in New York waiting for the arrival of another Thoroughbred stallion. The Thoroughbred's name was Geri, and he was coming home to the United States from Italy.

On the Old Friends website, Michael explained what it took to bring Geri back home: "Several years ago, Sylvia, our office manager, visited Geri in Italy and adored him. I also remembered him very fondly as a gorgeous and successful racehorse. I contacted Andrea Brancini at Horse America, the international equine shipping service, and he worked on all the arrangements once Geri became available. We are delighted to have brought Geri home."[206]

So now Michael and Nick found themselves waiting at the airport, eagerly looking forward to getting to see the latest Old Friends retiree.

> *We went up to the USDA Equine Animal Quarantine facility in Newburgh. The guy there was a really, really nice guy. I told him, "We've been working for a year and a half to get this horse back, and we drove all the way from Kentucky to see him. And I just want Nick to be able to get a picture."*

Sylvia Stiller discovered Geri on a trip to Italy with her husband, Jim. Today, Geri is retired at Old Friends. *Courtesy of Jim Stiller.*

*Now, you're not supposed to go into the quarantine facility, but then something happened. The guy said, "Why don't you just go around this way, go around that way and then go in that way, but don't touch him."*

*So, I go in, and Geri's on the truck, the Sallee Van truck. They brought the other two horses off, and Geri's the only one in there. So, I snuck in there, looked at him, and he gave me a kiss. It was fabulous.*

*Then he got off the truck. He was a little thin from the trip and all that, but he'll be fine.*[207]

A few weeks later, Geri was in Kentucky and was sent to Hurstland Farm, where Alfred Nuckols and his staff would take care of him until room became available at the main farm. In fact, in addition to Geri, a few other new horses were being boarded at Hurstland Farm again: Say Florida Sandy and Make Luck. And, a few mares as well: Our Revival and Black Tie Countess, whose sire was Black Tie Affair.

With Geri's arrival back home to the United States, in a way, Old Friends had come full circle. From the arrival of the first stallions—Sunshine and Creator—back in 2004, through all the growth of the farm over the last ten

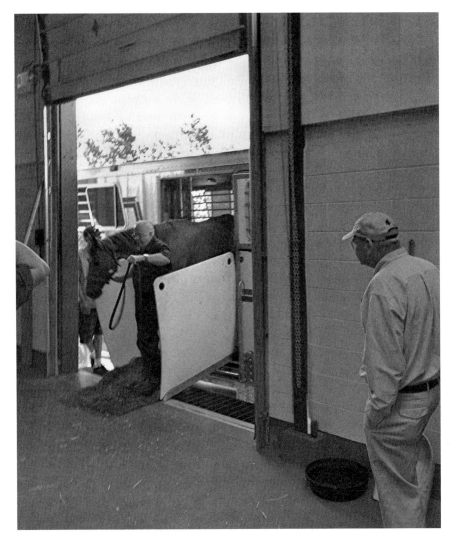

Michael Blowen watches Geri walk off a truck in New York. A few weeks later, Geri arrived in Kentucky, where he will enjoy his retirement at Old Friends. *Photo by Lord Nicholas Newman.*

years, to now having another horse return from overseas to be retired to Old Friends, the farm had undergone tremendous success, and its future seems to only be limited to the amount of space on the farm and its annexes.

Of course, while the farm has had some great success, there have been some rough patches as well. One of the toughest moments for Old Friends

came a few years ago when the bank threatened to foreclose on the farm's mortgage—due to its own error.

It seems that when Michael had refinanced the farm, the bank said that there had been a mistake. When the refinancing had been done, an adjustment was not made to Old Friends' payment plan. So, bottom line, Old Friends owed the bank more than $200,000, and it wanted it now.[208]

So, over the next several months, while Michael worked with the bank to renegotiate the loan, word got out through articles, e-mails and social media that Old Friends had a financial problem because of the banking error, and the response exceeded everyone's expectations.

"It took about a year and a half, but it was finally resolved," said Michael. "They withdrew their complaint from the sheriff's office in consideration for the amount of money we gave them and promises that we were going to make our mortgage payment. Subsequently, the mortgage has been rewritten, and we haven't missed a payment."[209]

One of the interesting things about all this is that if the bank had foreclosed, it would have been able to take everything *except* the horses. In an ironic twist of fate, one that also shows how some people regard horses and livestock in Kentucky, the horses were not considered "a part of the mortgage or the property."

"One of the great things about people looking at these horses as having no value is that they were never part of the collateral," said Michael. "The horses have never, never been part of the collateral. So, we always would have the horses, and we're the only ones who want to have them anyway."[210]

One of the other tough things that everyone has to deal with at Old Friends is the deaths of these great Thoroughbreds. Everyone knows that when these horses arrive at the farm, they are middle aged and older, and their time might be short. Still, everyone finds one or more favorites, and they become attached to them. When a horse dies, then, it affects someone on the farm.

Early in 2014, during one of the coldest winters on record in Kentucky, Old Friends suffered through a number of losses—all within a three-week period. On January 6, 2014, Patton passed away. Then the very next day came the toughest loss of them all, as Sunshine Forever, the farm's Foundation Stallion, passed away during the night.

For Michael, each time a horse dies, it affects him. But the death of Sunshine was the toughest one he ever experienced. "I have to say when I woke up that morning and I saw him down, I knew he was dead," said Blowen. "I went out

there, and I just couldn't believe it. I started to scream. It was like this scream that came from the marrow of my bones. I never made a sound like that in my life. I mean, it was just so agonizing. It was just awful."[211]

In the Old Friends newsletter sent out with Sunshine's obituary, Michael said, "Our foundation stallion, the Eclipse Award winner who we brought home after his breeding career was over, is dead, and there's nothing much more to be said...I don't think I've ever been sadder."[212]

Then, one week later on January 13, Dancin' Renee passed away. Still, as in all things, life moves on, and things come full circle. Within a few weeks of those tough losses at the farm, nine new horses arrived at the farm, including Catlaunch, Railtrip, Johannasbourbon, Geronimo, Silver Ray and Say Florida Sandy, to name just a few.

Also, earlier in 2014, Michael worked out a deal with a friend to lease the property next door to Old Friends on Paynes Depot Road, which added forty to fifty more acres to the farm.[213]

Along with the new land, some other changes occurred at Old Friends in 2014. Longtime farm managers Janet Beyersdorfer and Kent Ralston, who had done a nice job over the years taking care of the horses and the farm, left to pursue other opportunities.

In their place is Ron Wallace, who will work on the expansion and design of the new property, and Tim Wilson, who will oversee the care of the horses on a daily basis.

It's a cool spring day in 2014, and the sun is slowly setting over Old Friends. The shadows are growing longer. Some horses are grazing peacefully in their paddocks, while up the hill, a few others are running around and playing what seems to be a horse version of tag.

Like Old Friends itself, the horses' lives have come full circle once they arrive at Old Friends. When they were born, their lives were so simple. They went out each day into a large open pasture, where they grazed, napped, played and romped with the other foals in their paddocks and their moms close by.

Then these athletes, as Michael always refers to the horses, went to work, and they worked hard all their adult lives. They've trained, they've traveled, they've raced, they've overcome injuries and they've raced some more. When their racing careers were over, the stallions headed to the stud barn; the mares became moms, producing foals year after year, and the geldings went here and there.

It's another beautiful morning in Kentucky as Michael Blowen and Diane head out to begin the morning feeding. *Courtesy of author.*

So, when the lucky few Thoroughbreds arrive at Old Friends, they finally get to relax and enjoy retirement, because as Michael is fond of saying, "Once a horse arrives at Old Friends, they are the boss, and we [the people on the farm] are here to serve them…It's all about the horses at Old Friends, and they are free to live out their lives in a dignified and humane retirement."

In essence, they are free to return to the carefree time of their youth and can spend their days grazing, napping and running around their paddocks to their hearts' content.

They are free to come over to the fence when a tour arrives and be doted over by the thousands of visitors to the farm each year, or if they are not interested, they can just do what they want. It's up to them.

They are free to stand in the rain and get soaked, go inside their run-in shed or get down and roll in the mud and get as dirty as they want.

They are free to chase snowflakes during the winter, which is fun to watch. Some love the snow and will roll around in it, while others go hide in their run-in sheds and want nothing to do with it.

Once they arrive at Old Friends, for the first time since they were young foals, these great and wonderful Thoroughbreds are free to just be horses for the rest of their lives.

# Miss Hooligan

As many other people in this book have told a story about one of their favorite horses at Old Friends, I have one to tell about mine. She is a filly, and her name is Miss Hooligan.

SHORTLY AFTER I MET MICHAEL, we were talking one day when he received a phone call. He excused himself and walked a few steps away to take the call on his cellphone. It was not my intention to eavesdrop on the call, but something caught my attention, and I began to listen.

Michael was talking to someone about purchasing a horse—a horse that might soon have "an unfortunate end." It seemed the three-person deal Michael was trying to put together had fallen apart, as one person had to drop out. Listening more, I heard Michael say that they just needed to find one other person who could put up $500, and then they could purchase the horse.

Well, when I heard that, my heart skipped a beat. I had always wanted to own a horse, but knew I could never afford it. Maybe, just maybe, I thought to myself, this just might be my one-time opportunity. So, I walked over to Michael and tapped him on the shoulder. He put his finger up as if to say, "Hold on just a minute please." I tapped again, and his finger went up one more time. While I didn't know him that well at the time, and while I didn't want to irritate him, I tapped one more time.

I could tell he might not be too pleased as he said, "Hold on a second" to the person on the phone. He turned to me and asked, "What is it?"

I said, "Sorry. I didn't mean to listen. But are you saying you need someone with $500 to become part owner of a horse?"

Michael smiled a little at that and said, "Yes."

I said, "So all I have to do it put up $500, and then I don't have to spend any more money and I can become part owner of a horse?"

Michael said, "Yes."

I said, "Count me in."

Michael's smile beamed bright, and he said "Great!"

He got back on the phone with his friend, who turned out to be Old Friends volunteer Tim Ford, and told him that they had the third person and that they could go pick up the horse the next day at River Downs, which was a racetrack just across the northern Kentucky border in Ohio. (It is now called Belterra Park.)

So, the next morning, Michael and I got in his old convertible two-seat sports car and, with the top down, drove to River Downs. I met Tim, and we all went to the backside of the track. There, standing in a stall, was the most beautiful filly I had ever seen in my life. She was a bit thin, worn down, scruffy and nervous. But I did not care. To me she was gorgeous, friendly and wanted attention, and I was now one of her new owners.

The horse's name was Miss Hooligan. She was 3 years old at the time and had run in eleven races, with a best finish of second place. Her first race was, of all things, a two-turn race at Churchill Downs. In fact, if you look it up, you can find it on YouTube. In that race, she led all the way around the track. Then, when she came around that final turn and looked at that long Churchill Downs homestretch, it was as if she said to herself, "Okay, this was fun, but I've had enough," and she pretty much just stopped running and finished last.

What drew Michael to Miss Hooligan was that her broodmare sire was Sunshine Forever. When a trainer friend of his, Luis Arzola, called to tell him that she might be heading to possible slaughter, Michael jumped into action, and that's how the three of us ended up purchasing her.

A few days later, Miss Hooligan arrived at Steve Upchurch's farm, one of Old Friends' annex farms just north of Paris, Kentucky. There she stayed for a while until she was healthier. I visited her almost every Saturday, took hundreds of photos, gave her treats, spoiled her rotten and just absolutely enjoyed her company.

Soon she was healthy, and because she was so young and really not ready for retirement, Michael decided to lend her out to Boys' Haven in Louisville, a place for troubled teens. There, Miss Hooligan became a therapy horse for a while and, hopefully, helped out some of the children.

While I was happy she had a "job" to do, I really missed getting to visit her each week like I had been doing. I did get to go visit her in Louisville once, but it was a long drive, and I wasn't able to make that trip that much.

Around the same time Miss Hooligan went to Boys' Haven, I became unemployed and was having a tough time finding a job. After about a year of not finding work, I was not feeling really good with myself. In fact, to be honest, I was just about ready to give up looking for a job altogether.

Then, one day, totally out of the blue, Michael told me that he was going to bring Miss Hooligan home to Old Friends. He said that he was bringing her home for some reason or other. However, to this day, I truly believe that he brought her home so she could, in a sense, become a therapy horse for me.

Well, it worked. One day shortly after that, Miss Hooligan arrived at Old Friends, and they took her back to the mare's paddock. Then, every single morning after she arrived, I drove over to the farm, walked up the hill to the mare's paddock and visited her for an hour or so. It didn't matter what the weather was like; I made that walk to go see her and gave her some carrots and peppermints, her favorite treats.

On one of those walks, I had what is still my favorite memory of not just Miss Hooligan but of being a part of the Old Friends family. One cold, very rainy Saturday morning, I made my way up the hill to visit Miss Hooligan. When I arrived at the paddock, it was absolutely pouring down rain. The paddock was really wet, I was soaked to the bone, even in my raincoat, and I was getting colder by the minute. The mares were all huddled in their run-in shed, and they all seemed very content.

I called out "Miss Hooligan" in a sing-song kind of voice I always use when I call her, and that she learned to know, to see if she'd come out for a visit. But this time, I got no response. I called out again, "Miss Hooligan." No response again. I tried one last time, "Miss Hooligan," and all of a sudden, she popped her head out around the corner of the run-in shed and just looked at me. I could tell she wanted the treats she knew I had, but her expression seemed to say, "You know, it's really raining hard out there. Could you please bring the treats over here?" Yep, she was smarter than me. She knew it was better to stay inside on a rainy day.

So, anyway, I opened the gate, sloshed through the wet ground over to the run-in shed and walked inside, and there she was waiting for me, along with the other mares—Bonnie's Poker, Cozy Miss, Hidden Lake and Personalized. She nickered a greeting and then sniffed all my pockets where she knew I kept the treats. I gave her a few carrots and then walked around and gave the other mares a few carrots each as well.

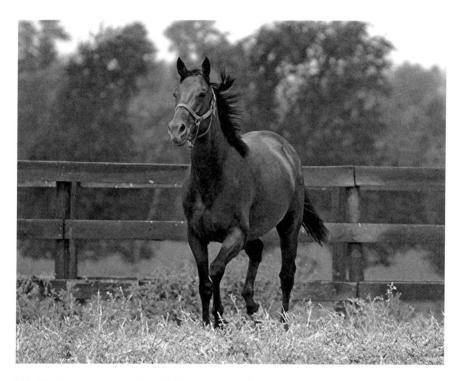

Miss Hooligan runs around exploring her new paddock upon arriving at Old Friends in Georgetown, Kentucky. *Courtesy of author.*

Then I came back to Miss Hooligan, and for about thirty minutes or so, I stood next to Miss Hooligan and leaned on her a little to get warm, and she leaned on me a little, too. Together, we just stood there enjoying each other's company as we looked out across the beautiful open field of green grass in the mare's paddock. There was almost total silence. Nothing except for the soft *pitter-patter* of raindrops falling on the roof of the run-in shed, the occasional swish of a tale, a soft nicker and the calm breathing of all the mares.

For those few minutes, standing there with Miss Hooligan, with only the sounds of Mother Nature around us, I truly believe I know what heaven must be like.

All too soon, I knew I had to start the walk back down the hill so I could head home and get on with the job hunt. I truly hated to have to break up that moment though. It was just so special.

Reluctantly, I gave her one last pat, one last kiss on the nose and walked back out into the rain to the gate. When I stopped to open it, I got a nudge from behind. I turned around, and there she stood. She had followed me out

into the rain to the gate and was just standing there looking at me as if to ask, "Do you have to go?"

Now, I know there are some people who will just say I'm being foolish and just transferring human emotions to a horse. But I don't care because at that moment, in my heart and in my mind, I truly believe that she had enjoyed those few minutes with me in the run-in shed as much as I enjoyed spending them with her, and she didn't want it to end either.

I kissed her on the nose one more time, made my way out of the paddock and started the long walk down the hill. I looked over my shoulder, and she was still standing there watching me walk away before turning and heading back to the run-in shed.

Miss Hooligan and I have had a lot of enjoyable moments together before and after that one time. And I did finally find a job. But those thirty minutes with her in that run-in shed that Saturday morning in the rain were just so enjoyable and meant so much to me. I will always remember it.

It's kind of funny, but every time I walked back to see her now, in my head I can hear Smokey Robinson singing a song in my head. You know the one: "My girl, talking about my girl…" There's no question that Miss Hooligan has three owners who care about her, but to me, she will always be My Girl—the sweetest girl in the whole world.

# Appendix B
# Old Friends

## Roster of Horses

*As of June 2014.*

## OLD FRIENDS: HORSES IN KENTUCKY

Affirmed Success
Afternoon Deelites
Al The Bingel
AP Slew
Areyoutalkintome
Arson Squad
Ascending Haze
Ava Lotta Hope
Baie Prospector
Ball Four (2001)
Black Tie Countess
Bobby Sands
Bonapaw
Bonfante
Bon Marie
Boule D'Or

Burwood
Cappucino Kid
Catlaunch
Cherono
China Bank
Circus Bank
Commentator
Creator (GB)
Danthebluegrassman
Delay of Game
Diamond Stripes
Dinard
Discreet Hero
Duke Ora
Du Pars
Early Pioneer

Easy Grades
El Brujo
Eldaafer
Escapedfromnewyork
Fabulous Strike
Falcon Scott
Ferocious Won
Flick
Futural
Gallapiat's Moment
Gasconade
Geri
Geronimo
Gulch
He Loves Me Not
Hidden Dark
Hidden Lake
Hussonfirst
Ident
I'm Charismatic
Johannesbourbon
Judge's Case
Keg of Dynamite
King James
Kiri's Clown
Kudos
Little Silver Charm
Lusty Latin
Make Luck
Makors Mark
Malibu Mix
Mark of Success
Marshall Rooster (GB)
Max A Million
Maybesomaybenot
Mighty Mecke
MiketheSpike

Miss Docutech
Miss Hooligan
Misszoey Belle
Mixed Pleasure
Mythical Pegasus
Northern Stone
Ogygian
One World
Our Revival
Popcorn Deelites
Prized
Rail Trip
Rapid Redux
Ready's Rocket
Regal Sanction
Riva Way
Santona (Chi)
Sarava
Say Florida Sandy
Sea Native
Sean Avery
Seek Gold
Sgt. Bert
Shadow Caster
Silver Ray
Siphonizer
Slamming
Smokey Stover
Special Ring
Star Plus (Arg)
Stormy Passage
Summer Attraction
Swan's Way (1989)
Terryhowieandjimmy
Thornfield
Tinners Way
Tour of the Cat

Ukiah
Victor Cooley
Wallenda
W.C. Jones

Westmoreland Road
Williamstown
You and I

# Old Friends at Cabin Creek, the Bobby Frankel Division: Horses in New York

Behrens
Cool N Collective
Karakorum Patriot
Lorccan
Midnight Secret
Moonshadow Gold

Red Down South
Roaring Lion
Thunder Rumble
Watchem Smokey
Will's Way
Zippy Chippy

# Deceased: Kentucky Horses

Academy Award
Appygolucky
Ascending Haze
Awad
Ballindaggin
BenBurb
Bingo
Black Tie Affair (Ire)
Bonnie's Poker
Bull InThe Heather
Buzzovertomyhouse
Charming Dreamer
Clever Allemont
Cozy Miss

Criminal Type
Dancin' Renee
Dusty Fields
Easy Ellis
Estrapade
Eternal Orage
Flying Pidgeon
Fortunate Prospect
Fraise
Gabfest
Glitterman
Gold Spring (Arg)
Invigorate
Jade Hunter

Kano Doble
Klassy Briefcase
Leave Seattle
Madeo
Magic Dot
Marquetry
Narrow Escape
Occasion
Patton
Personalized
Polish Navy

Precisionist
Proper Reality
Richard's Lass
Ruhlmann
Stage Colony
Steel Robbing
Sunshine Forever
Taylor's Special
The Name's Jimmy
The Wicked North
Windundermywings

## Deceased: Cabin Creek New York Horses

Crusader Sword
Key Contender
New Export

## Old Friends Horses: Not on the Farm

BluestheStandard
Free Spirits Joy
Gameday News
Salzburg
Wallace Station
Zuppardo's Big Boy

# Notes

## INTRODUCTION

1. Interview with Michael Blowen, August 8, 2008.
2. Interview with Marion Alteiri, July 16, 2008.
3. Ibid.
4. Ibid.
5. Ibid.
6. Ibid.
7. Ibid.
8. Ibid.
9. Interview with Michael Blowen, August 8, 2008.
10. Ibid.
11. Ibid.
12. Interview with Marion Alteiri.
13. Ibid.

## CHAPTER I

14. Rick Capone, "Remembering a Champion: Sunshine Forever," *Woodford Sun*, January 16, 2014, 11; interview with Michael Blowen, July 5, 2008.

15. Old Friends website, http://www.oldfriendsequine.org.

16. Brisnet.com, Sunshine Forever, lifetime past performances.

17. Keeneland Library, race chart on microfiche.

18. Ibid.

19. Brisnet.com, Sunshine Forever, past performances.

20. Keeneland Library, race chart on microfiche.

21. Ibid.

22. Ibid.

23. Ibid.

24. Ibid.

25. Ibid.

26. Ibid.

27. Brisnet.com, Sunshine Forever, lifetime past performances.

28. Ibid.

29. Ibid.

30. *BloodHorse*, "Sunshine Forever Retired," November 18, 1989.

31. Old Friends website.

32. A conversation with Michael Blowen, January 2014.

33. Interview with Michael Blowen, July 5, 2008.

34. Capone, "Remembering a Champion."

## CHAPTER 2

35. Rick Capone, "The Stars Shine Bright at 'Old Friends,'" OhmyNews, July 14, 2008, http://english.ohmynews.com/articleview/article_view. asp?no=383122&rel_no=1.

36. Ibid.

37. Ibid.

38. Ibid.

39. Ibid.

40. Ibid.

41. Ibid.

42. Ibid.

43. Ibid.

44. Ibid.

45. Ibid.

# Chapter 3

46. Interview with Michael Blowen, August 28, 2013.
47. Ibid.
48. Ibid.
49. Ibid., June 28, 2008.
50. Mike Mullaney, "The Story of Exceller," *Daily Racing Form*, July 20, 1997, available on Exceller Fund website, http://www.excellerfund.org/story-of-exceller.html.

# Chapter 4

51. Interview with Michael Blowen, June 28, 2008.
52. Ibid.
53. Ibid.
54. Capone, "Stars Shine Bright."

# Chapter 5

55. Interview with Michael Blowen, February 5, 2014.
56. Interview with Alfred Nuckols, February 14, 2014.
57. Lenny Shulman, "Sunshine Forever, Creator Arrive at Old Friends," *BloodHorse* magazine online, November 4, 2004, http://www.bloodhorse.com/horse-racing/articles/25241/sunshine-forever-creator-arrive-at-old-friends.
58. Interview with Michael Blowen, September 25, 2014.
59. Interview with Alfred Nuckols, February 14, 2014.
60. Ibid.
61. Interview with Michael Blowen, September 25, 2014.
62. Ibid.
63. Ibid.
64. *BloodHorse*, "Champion Estrapade Dies at Age 25," February 25, 2005, http://www.bloodhorse.com/horse-racing/articles/26869/champion-estrapade-dies-at-age-25#ixzz2uwYYapQh.

65. Interview with Alfred Nuckols, February 14, 2014.
66. Ibid.
67. Ibid.
68. Ibid.

# Chapter 6

69. *Meet at Old Friends: Creator*, DVD No. 1, by Tim Wilson of WinPlaceSold. com, February 15, 2012, available at http://www.youtube.com/watch?v=mi6WGw4AvnA.
70. Interview with Diane White, March 6, 2014.
71. *Meet at Old Friends: Creator.*
72. Ibid.
73. Interview with Alfred Nuckols, February 14, 2014.
74. Ibid.
75. Interview with Michael Blowen, July 13, 2008.
76. Ibid.
77. David Schmitz, "Silver Charm's Dam, Bonnie's Poker, Dies," BloodHorse. com, August 5, 2010.
78. Ibid.
79. Old Friends website, "Bonnie's Poker 1982–2010," http://www. oldfriendsequine.org/articles/bonnies-poker-1982---2010.html.
80. Ibid., "Taylor's Special 1981–2006," http://www.oldfriendsequine.org/articles/taylors-special-1981---2006.html.
81. Interview with Alfred Nuckols, February 14, 2014.
82. Interview with Michael Blowen, September 25, 2014.
83. Ibid.
84. Old Friends website, "Taylor's Special 1981–2006."
85. Interview with Alfred Nuckols, February 14, 2014.
86. Old Friends website, "Fraise 1988–2005," http://www.oldfriendsequine. org/articles/fraise-1988---2005.html.

# Chapter 7

87. Interview with Alfred Nuckols, February 14, 2014.
88. Interview with Michael Blowen, July 13, 2008.
89. Ibid.
90. Ibid.
91. Ibid.
92. Ibid.

# Chapter 8

93. Ibid., July 5, 2008.
94. Ibid.
95. Ibid.
96. Ibid.
97. Ibid.
98. Ibid.
99. Ibid.
100. Ibid.
101. Phone conversation with Michael Blowen, February 2014.

# Chapter 9

102. Old Friends website, "Gulch," http://www.oldfriendsequine.org/horses/gulch-637.html.
103. Interview with Michael Blowen, April 11, 2013.
104. E-mail interview with Kent Desormeaux, January 7, 2014.
105. Old Friends website, "The Wicked North," http://www.oldfriendsequine.org/articles/the-wicked-north.html.
106. Ibid.
107. Ibid., "Hidden Lake," http://www.oldfriendsequine.org/horses/hidden-lake-559.html.

108. E-mail interview with Barbara Fossum, March 6, 2014.

109. Old Friends website, "Black Tie Affair 1986–2010," http://www.oldfriendsequine.org/articles/black-tie-affair-1986---2010.html.

110. Ibid.

111. E-mail interview with Delores Hopkins-Poulos, January 15, 2014.

112. Old Friends website, "Black Tie Affair."

113. E-mail interview with Delores Hopkins-Poulos, January 15, 2014.

114. Old Friends website, "Black Tie Affair."

115. Ibid.

116. Ibid., "Precisionist," http://www.oldfriendsequine.org/articles/precisionist-1981-2006.html.

117. Ibid.

118. Ibid.

119. Ibid., "Sarava," http://www.oldfriendsequine.org/horses/sarava-4260.html.

120. Lenny Shulman, "Phoenix Rising: Sarava's Owner Savors Victory," BloodHorse.com, June 11, 2002, http://www.bloodhorse.com/horse-racing/articles/10024/phoenix-rising-saravas-owner-savors-victory.

## CHAPTER 10

121. Interview with Michael Blowen, February 23, 2014.

122. E-mail interview with Kent Desormeaux, January 7, 2014.

123. Old Friends website, "Afternoon Deelites," http://www.oldfriendsequine.org/horses/afternoon-deelites-3285.html.

124. Ibid., "Mixed Pleasure," http://www.oldfriendsequine.org/horses/mixed-pleasure-4329.html.

125. E-mail interview with John Bradley, April 14, 2014.

126. Old Friends website, "Clever Allemont," http://www.oldfriendsequine.org/horses/clever-allemont-154.html.

127. Ibid.

128. Ibid.

129. Ibid.

130. E-mail interview with Jane White, January 6, 2014.

131. Ibid.

132. Old Friends website, "Flying Pidgeon 1981–2008," http://www.oldfriendsequine.org/articles/flying-pidgeon-1981---2008.html.

133. Wikipedia, "Ogygian," http://en.wikipedia.org/wiki/Ogygian.

134. Ibid.

135. Old Friends website, "Flying Pidgeon 1981–2008."

136. E-mail interview with Beth Tashery Shannon, February 28, 2014.

137. Joe Nevills, "Bull Inthe Heather, Florida Derby Winner, Dies at Old Friends," *Daily Racing Form*, http://www.drf.com/news/bull-inthe-heather-florida-derby-winner-dies-old-friends.

138. Old Friends website, "Bull InThe Heather," http://www.oldfriendsequine.org/horses/bull-inthe-heather-16.html.

139. Ibid., "Danthebluegrassman," http://www.oldfriendsequine.org/horses/danthebluegrassman-37.html.

140. Ibid., "Flick," http://www.oldfriendsequine.org/horses/flick-547.html.

141. Ibid.

142. Ibid., "Arson Squad," http://www.oldfriendsequine.org/horses/arson-squad-4107.html.

143. E-mail interview with Samantha Siegel, February 9, 2014.

144. Old Friends website, "I'm Charismatic," http://www.oldfriendsequine.org/horses/im-charismatic-981.html.

145. E-mail interview with Mary Adkins-Matthews, February 5, 2014.

146. Ibid.

147. Ibid.

148. Ibid.

149. Ibid.

150. Old Friends website, "Popcorn Deelites," http://www.oldfriendsequine.org/horses/popcorn-deelites-25.html.

151. Ibid., "Special Ring," http://www.oldfriendsequine.org/horses/special-ring-28.html.

152. Ibid., "Kiri's Clown," http://www.oldfriendsequine.org/horses/kiris-clown-63.html.

153. Ibid., "Awad 1990–2011," http://www.oldfriendsequine.org/articles/awad-1990---2011.html.

154. Ibid., "Swan's Way," http://www.oldfriendsequine.org/horses/swans-way-31.html.

155. Interview with Tom Beatty, February 19, 2014.

156. Old Friends website, "Marquetry 1987–2013," http://www.oldfriendsequine.org/articles/marquetry-1987---2013.html.

157. Ibid.

158. Ibid., "Commentator," http://www.oldfriendsequine.org/horses/commentator-560.html.

159. Ibid.

160. Ibid.

161. Ibid., "Appygolucky 1997–2009," http://www.oldfriendsequine.org/articles/appygolucky-1997---2009.html.

162. Interview with Vivian Morrison, January 26, 2014.

163. Ibid.

164. Old Friends website, "Williamstown," http://www.oldfriendsequine.org/horses/williamstown-33.html.

165. Unpublished article by Rick Capone.

166. Old Friends website, "Tinners Way," http://www.oldfriendsequine.org/horses/tinners-way-3738.html.

167. Ibid., "Kudos," http://www.oldfriendsequine.org/horses/kudos-21.html.

168. Ibid., "Cherono," http://www.oldfriendsequine.org/horses/cherono-623.html.

169. Info on James and Dennis Richard on the NTRA website, http://files.ntra.com/stats_bios.aspx?id=7015.

170. Ibid.

171. Old Friends website, "Bonapaw," http://www.oldfriendsequine.org/horses/bonapaw-574.html.

172. Ibid., "Affirmed Success," http://www.oldfriendsequine.org/horses/affirmed-success-12.html.

173. Ibid., "Futural," http://www.oldfriendsequine.org/horses/futural-19.html.

174. Ibid., "Sea Native," http://www.oldfriendsequine.org/horses/sea-native-592.html.

175. Interview with Angela Black, April 12, 2014.

176. Old Friends website, "Delay of Game," http://www.oldfriendsequine.org/horses/delay-of-game-12770.html.

177. Interview with Dagmar Galleithner Steiner, April 8, 2014. See her website at www.galleithner.com.

178. Old Friends website, "Riva Way," http://www.oldfriendsequine.org/horses/riva-way-26.html.

179. Old Friends in-house files.

## CHAPTER 11

180. Interview with Michael Blowen, February 12, 2014.

181. Ibid.

182. *BloodHorse*, "Old Friends Satellite Opens in NY," November 18, 2009, http://www.bloodhorse.com/horse-racing/articles/53497/old-friends-satellite-opens-in-ny.

183. Ibid.

184. Ibid.

185. Paul Post, "Old Friends at Cabin Creek: The Bobby Frankel Division for Retired Racehorses Has Its Official Grand Opening in Greenfield Center," *The Saratogian*, July 23, 2010, http://www.saratogian.com/general-news/20100723/old-friends-at-cabin-creek-the-bobby-frankel-division-for-retired-racehorses-has-its-official-grand-opening-in-greenfield-center.

186. Old Friends website, "Thunder Rumble," http://www.oldfriendsequine.org/horses/thunder-rumble-631.html.

187. Ibid., "Will's Way," http://www.oldfriendsequine.org/horses/wills-way-34.html.

188. Ibid., "Red Down South," http://www.oldfriendsequine.org/horses/red-down-south-984.html.

189. Ibid., "Zippy Chippy," http://www.oldfriendsequine.org/horses/zippy-chippy-0.html.

190. Ibid.

## Chapter 12

191. Interview with Sylvia Stiller, February 10, 2014.

192. Interview with Alfred Nuckols, February 14, 2014.

193. Interview with Sylvia Stiller, February 10, 2014.

194. Interview with Michael Blowen, August 28, 2013.

195. Ibid.

196. Interview with Dr. Doug Byars, February 8, 2014.

197. Interview with Michael Blowen, August 28, 2013.

198. Ibid.

199. Interview with Dr. Doug Byars, February 8, 2014.

200. Ibid.

201. Interview with Michael Blowen, August 28, 2013.

202. Ibid., February 12, 2014.

203. Ibid.

204. Interview with Rosie Napravnik on "Hats and Horses," http://hatsandhorses.wordpress.com/2013/10/09/a-passion-for-horses-an-interview-with-rosie-napravnik.
205. Ferdinand's Ball website, www.ferdinandsball.com.

# Chapter 13

206. Old Friends website, "Geri," http://www.oldfriendsequine.org/horses/geri-12730.html.
207. Interview with Michael Blowen, August 28, 2013.
208. Ibid., January 27, 2014.
209. Ibid.
210. Ibid.
211. Capone, "Remembering a Champion."
212. Old Friends newsletter, January 2014.
213. Nicole Russo, "Old Friends Plans Expansion to Kentucky Facility," *Daily Racing Form*, January 2, 2014, http://www.drf.com/news/old-friends-plans-expansion-kentucky-facility.

# About the Author

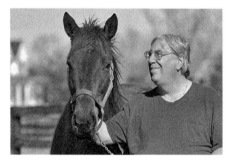

Rick Capone is a volunteer at Old Friends and is currently the sports editor for the *Woodford Sun* in Versailles, Kentucky, which is near Lexington. He has been in the writing profession since 1985, starting as a technical writer with IBM while also doing some freelance sports writing, mostly about his favorite sport, volleyball.

In 2006, Rick moved to Lexington, Kentucky, to work as editor of *Coaching Volleyball* magazine for the American Volleyball Coaches Association, and soon he discovered that he had a passion for something bigger than volleyball: horses.

In 2009, he visited Old Friends, where he met Michael Blowen and approached him with the idea of writing a book about the horses of Old Friends. Michael liked the idea, and they began the project. However, at the time, Old Friends began accepting so many horses that Rick couldn't keep up, and the project was put on hold.

In 2014, things came full circle when The History Press approached Michael about doing a book on the history of Old Friends. Michael suggested Rick for the project, and the result is the book you are holding today.

*Visit us at*
www.historypress.net
........................................................
*This title is also available as an e-book*